Cats in the Sun

Hans Silvester

CHRONICLE BOOKS

SAN FRANCISCO

First published in North America in 1994 by Chronicle Books.
First paperback edition 1995.
Copyright © 1993 by Editions de la Martinière.
All rights reserved. No part of this book may be reproduced
in any form without written permission from the Publisher.

Cover Design: Tally Sue Tom

Library of Congress Cataloging-in-Publication Data

Silvester, Hans Walter.
 [Chats du soleil. English]
 Cats in the sun/Hans Silvester.
 p. cm.
 ISBN 0-8118-1093-3
 1. Cats—Greece—Cyclades—Pictorial works.
 2. Cats—Greece—Cyclades. I. Title.
SF442.63.G8S5413 1994
636.8'009499—dc20 93-33436
 CIP

Distributed in Canada by
Raincoast Books
8680 Cambie Street, Vancouver, BC V6P 6M9

10 9 8 7 6 5 4 3 2

Chronicle Books
275 Fifth Street
San Francisco, California 94103

Printed in Italy

Cats in the Sun

Hans Silvester

I ought to begin with the Greeks, and especially those who live in the Cycladic Islands. They are at the heart of this book. They don't often appear in my photographs, but, without them, the cats would not survive. The climate allows the islanders to spend much of their life outdoors and the cats share that Mediterranean habit. Indoors, their living rooms are like museums–full of family mementoes, religious objects, decorative plates, vases round the television and mini-bars. Cats are forbidden to cross the threshold: Greeks allow no pets in their homes, except for their canaries. Yet the cats are true domestic cats, not abandoned or wild, and they have for centuries shared the lives of human beings. The Greek islanders like them without exactly loving them, they care *for* them without exactly caring *about* them; but they totally accept them. Cats are an inseparable part of everyday life: they have always been there, like the wind, the sun, the sea, day, and night.

My first stay on Mykonos was in 1982. I was instantly enchanted by the light and the architecture. I photographed some cats without really registering the force of their personalities.

A later trip took me to the Cyclades to photograph the dove-cotes. This time I developed a passion for the cats, and we became friends. Subsequently, over three years, I observed them at all hours of the day and night, and through every season, with all the patience needed to disturb them as little as possible. To the Greeks, I quickly became the fool who runs after the cats. I made them smile, but it was with the greatest kindness that they brought me coffee and cakes and told me stories about their favorite cats during the long hours that I waited for the best moment to take my photographs.

At home, in Provence, we have had cats in our household for more than thirty years. They are a part of our everyday life. These Provençal cats are similar to the cats of the Greek islands, yet not the same. They are more attached to the people and the house, losing something of their social instinct amongst themselves. They are distinctly more individualistic. Our present cat is called Greco. When he chose me as his adoptive father, he was a tiny kitten abandoned in the port of Hydra. Now he's a real tom-cat with plenty of personality–he's very friendly and very engaging. We have never had a cat that could purr quite as loud as Greco. (The paw prints in this book are his.)

Whatever island you visit, Mykonos, Milos, Santorin, Tinos, Syros, Amargos, Folegandros, Sifnos, Paros, or Naxos, you will be struck by the vast population of cats. They come in all colors–white, black, grey, ginger, striped—and in every conceivable and inconceivable mixture. The Greeks are very generous in feeding them: fishermen throw them their damaged catch and fishmongers always set aside a portion for them.

In return, the islanders hope to be spared the bother of rats and mice. Indeed, the ancient link between human, cat, and rodent still exists in the islands. The more confined the space, the greater the importance the cats serve as protectors of food, and especially, of seed-corn. Cats are powerful allies in the rodent war: an ordinary village cat can easily catch three hundred mice a year, judging by our cat Greco. If you think how quickly mice reproduce, you will realize how important cats are in rural areas for keeping them under control. Females are much better hunters than males. Although some cats find full-grown rats a problem, most deal with young rats as easily as they do with mice.

In many countries the development of chemical poisons has radically altered the relationship between people and rodents, and we have quickly forgotten what our ancestors suffered: seed-corn and harvests damaged or lost, disease engendered and spread. This is still the situation today in many parts of the world, such as India, where it is reckoned that twenty-five percent of the harvest is lost to rats and mice.

When the great navigators of past centuries set sail to discover new worlds, they were always accompanied by cats. Ships' cargoes were particularly susceptible to rodent infestation. Supplies were constantly threatened, and to protect them sailors kept cats in the holds of their ships. Cats were as much a part of the equipment as the anchor, the sails, and the compass. In fact, it was impossible to register or insure a ship that had no cat aboard. The British Royal Navy provided for the maintenance of cats on warships as late as 1975. (André Malraux provides a striking example of how a lack of cats cost the French the battle of Agincourt in 1415: while the English kept their weapons in cat-patrolled stores, the gut cords of the French crossbows, left unguarded, were gnawed through by rats). Without cats to protect their oats, the horses that led Pizarro to victory over the Incas would have starved; consequently, cats have played a shaping role in world history.

Cats are ill-suited to life on-board a ship, which they suffer only under strong coercion, and they care little for traveling. It is thus totally against their own will that they have succeeded in conquering every corner of the globe. One thing is certain, cats were always ready to jump ship if they had the opportunity, even if it meant swimming to shore; thus, these water-hating animals can be found on almost every island in the world.

The inhabitants of the Cyclades are poised between Europe and Asia, and their way of life reflects their dual inheritance. They don't pamper their domestic animals, but neither do they torment them, as people do farther east. People and cats alike live a simple life and know how to be happy in their day-to-day existence. Cats retain their independence: their friendship with the human race extends only so far, and it is they who set the limits.

In the industrialized West, domestic animals are often over-indulged, spoiled, and smothered with

affection. It is the cats that have adapted best to this new way of life, even if the universe of their urban milieu has become ever more restricted, and alley cats have been transformed into parlor pets. In the old days they might at least have had a garden; now they may not even be able to look out of the window. As an ultimate refinement of domestication, cats are de-clawed to protect the furniture.

In the Greek islands, cats lead a very different life. Each lives in his or her own district, where every morning the toms go out for a stroll and mark with a squirt of urine the boundaries of their territory. Within the district, they know every house, garden, roof, shrub, tree, and hiding-place. They also know every inhabitant, human or animal. They see a dog at a distance, and know at once how to behave towards that particular creature. People, too, hold no mysteries, and they know to the last detail every shift and nuance in the rhythm of village life: precisely when and in what house leftovers will be put out for them, when the fishermen come back into port—and a great deal more. In the same way, the village cats know who is fond of them, who tolerates them, and who hates them, and they adjust their manners accordingly. Their understanding of people is unerring, and their judgment acute. The slightest change in their world is cause for surprise: a new smell, no matter how faint, arouses their curiosity; at an unexpected sound they instantly awake. A rat or a mouse is unlikely to penetrate this world unobserved. When a cat becomes aware of a rodent, her attitude changes instantly. She freezes, and waits for her prey with amazing patience. When the rodent appears, the cat leaps, pins it down with her forepaws, and grips it in her fangs. The subsequent fate of the poor mouse has been vividly described by Jean-Louis Hue (*Le Chat dans Tous Ses États*): "The game heats up. Politely, the cat helps her prey to play its part. Standing on her hind legs, she holds it in her forepaws like a mother kangaroo with her baby. Then the pair seem to leave the earth altogether. Paws outstretched, in a whirlwind of excitement, the cat raises her victim up as high as possible before dropping it. What a wonderful game, she thinks, if only the mouse could fly! But it drops down heavily. The cat follows, light as a feather, pacified by her aerial exertions, and for a moment feigns exhaustion, before love of the game spurs her on. Such a charming playmate cannot be allowed to die: the cat tries to revive it by little taps of her paw. Each playful pat is a wounding blow, but heedlessly she goes on, stubbornly trying to coax a response equal to hers in vitality. Death, when it comes, satisfies the hunter, but disappoints the player."

Cats form part of the village community, naturally, but they get no more than food from the inhabitants. If anyone speaks to them they purr with delight, and their greatest pleasure is to rub against your legs; only very rarely, however, will they permit themselves to be stroked, hating the crackle of static electricity in their fur. Greeks do not normally give names to their cats, calling them simply *Gata or Gatila* (cat or kitty). In some villages, you will find a woman or perhaps a man who is the self-appointed guardian of strays. But if cats become too numerous in any given area their general health declines, epidemics break out, and many die—or a restaurant owner, exasperated by the crowd of cats haunting his terrace, resorts to poison.

Sometimes a really exceptional tomcat can dominate

a whole neighborhood. He is so strong, so cunning, and so handsome that people spoil him, and even greet him in the street. Other toms, awed, keep the peace when he is around. Since he seldom fights he is always in prime condition, and his success with cats in heat is reflected the next spring in the color of the kittens.

Cats within a neighborhood know one another extremely well; those on the periphery are familiar, but not intimate associates. A strange cat venturing into an alien neighborhood is immediately ejected, and a strange dog is greeted by a bristling of fur. Dogs usually know better than to risk confrontation, and instead lurk in hiding places from which they can see without being seen. Female cats will attack only if their kittens are in danger; their action then is swift, sudden, and fearless, and the astonished foe turns its tail in terror.

To be really congenial, a neighborhood needs a ruined house, an old stable, or an abandoned courtyard where wild passions are consummated and female cats give birth. For a few weeks, it is the gathering place for all the local cats, a secret retreat where their revelry is betrayed only by amorous yowls (Kittens in the same litter often have different fathers.) Cats have other strong emotions, too, chief among them is jealousy. Common disputes are settled among acquaintances in minor fights. In serious fights, however, claws become fearful weapons, blood soon flows, and terrible injuries are inflicted; it is not uncommon for one of the combatants to lose an eye.

Every day, the cats spend hours grooming themselves, licking their fur and using a moistened paw to wash their heads.

In these communities, there are two sorts of marginal citizens. On one side are the privileged individuals who belong to someone. While they are not allowed inside the house, the doorstep is theirs; they are regularly fed, and may even receive extra rations on demand; sometimes they serve as living toys for the children of the family. Fatter and less wild, these cats are easily spotted. They are no less free than the rest, but enjoy much better conditions. At the opposite extreme are those cats who are tramps by temperament and refuse to fit in, scavenging beyond the boundaries of any given neighborhood. They are the ones that you see first when you land—near the dustbins, on the restaurant terraces, and haunting the harbor. In fights, they always lose to their more established brethren. Their diet is irregular, feast one moment, famine the next, nearly always very poor in quality. They are often ill, and they die young.

A cat's position in the social order seems to be established at a very early age. Some kittens are adopted and find homes; most join the neighborhood group; a few remain solitary outsiders. The social behavior of cats is complex and difficult to interpret. Each one has its own personality. Because of their strong sense of individuality, cats can never accept a rigid organization, and they do not form packs or groups.

Domestic cats need human beings, and their lives become progressively more difficult the greater the distance that separates them. Cats need not only food, but affection. By nature they must purr, and they would rather purr in human company. On some islands I witnessed a genuine harmony between the species that gave equal pleasure to both sides. Cats manifest through their behavior just how happy they are.

Cats spend much more time asleep than humans, and their daily rhythm is very different. Their sleep is more

like a series of naps. Depending on the season, they rest in the welcome warmth of the winter sun or in cool summer shade. Their naps, somewhere between a dreamy doze and deep sleep, suit them perfectly, and no other animal is as adept at napping; conversely, without these short dozes cats cannot survive. Cats alternate between sleep and alertness right through the day and night. In the dark they are as deft as during the day, relying on their adaptable eyesight, their memory, and their keen tactile sense.

T he more severe and straight-edged the architecture, the less happy the cat. Cats like free forms, changes of level, curves, angles, irregularity, and mixed materials. The white villages of the Cyclades suit them perfectly. Cats live on two levels— on the flat roofs as much as on the ground, using balconies as springboards to sail across the narrow streets. When they need to, they can find good hiding-places from which to observe the rest of the world; it is an environment that suits cats better than dogs, and here they are at an advantage, able to make themselves heard and to watch any movement near or far. If architects paid more attention to the feelings of cats, we would live in much more pleasant homes. Planning and building of cities went wrong long ago, to the detriment of domestic animals even more than of people. In the Cyclades, cars cannot get into the hearts of villages and towns; the streets, made to the measure of pedestrians and donkeys, are too narrow. This contributes much to the well-being of cats, dogs, and people.

Our domestic cats are descended not from the European wildcat but from the Abyssinian cat, a native of the African deserts. In ancient Egypt, cats were sacred and their bodies were preserved by mummification; mistreatment of a cat was a capital offense. Where the cats of the Cyclades came from originally is uncertain, but they must have arrived by boat, a long time ago. Cats are depicted on many ancient Greek vases. Without their cats, the villages on the islands dotting the Aegean sea would be different, much less vital, places. The silhouettes of cats against the white houses are as much a part of them as the blue paint on doors and windows.

To live in harmony with their environments and enjoy the pleasure of life—such seems to be a cat's whole *raison d'être*. In this book, I have sought to show the quality of life of these island cats. I have also come to understand just how much human beings and cats have in common, especially when they are happy.

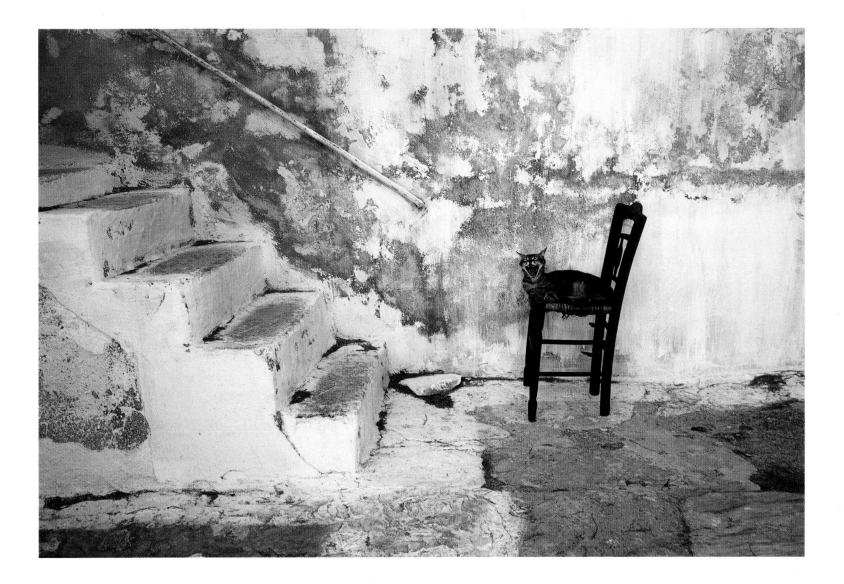

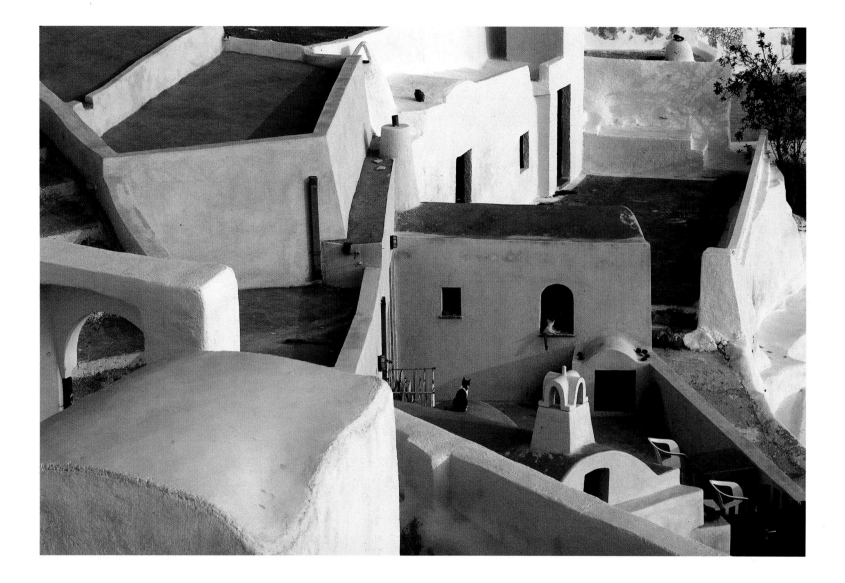

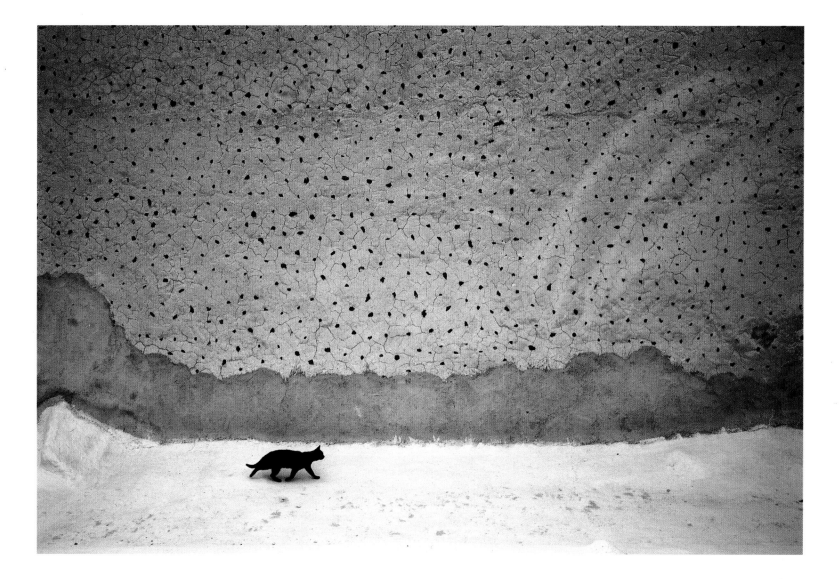

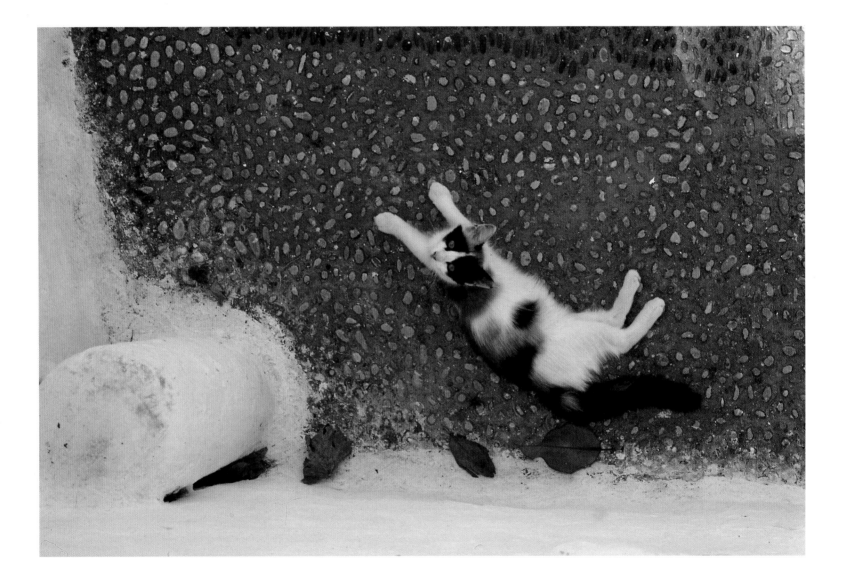

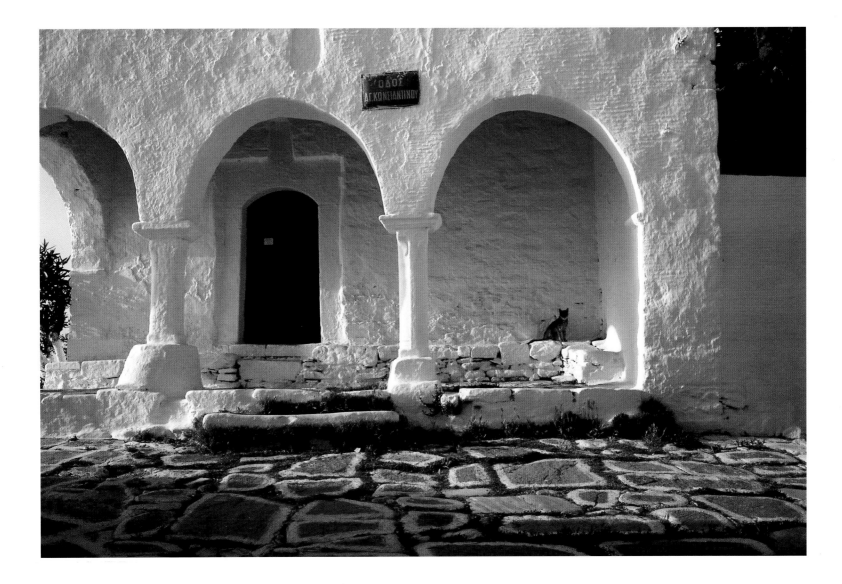

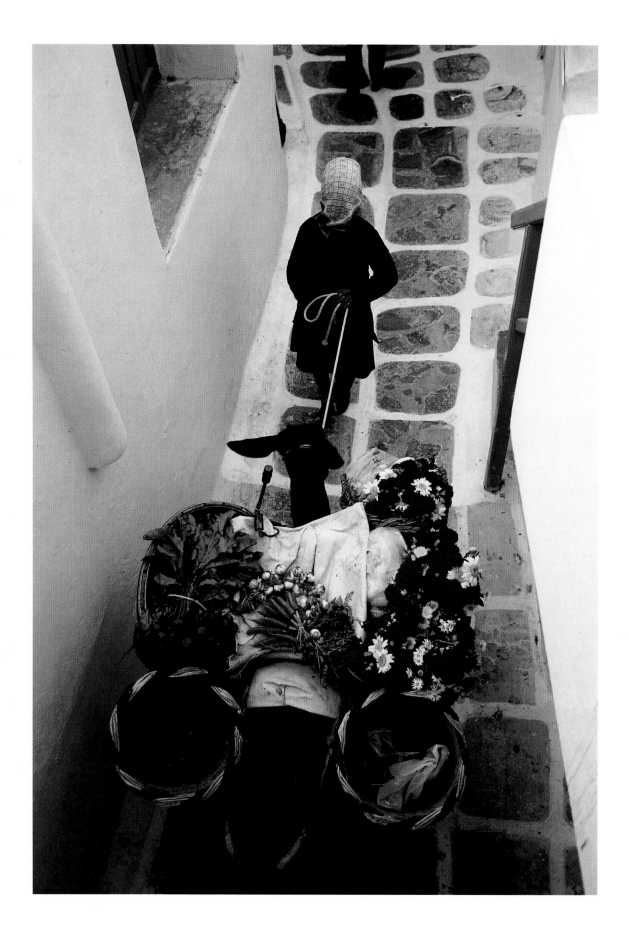

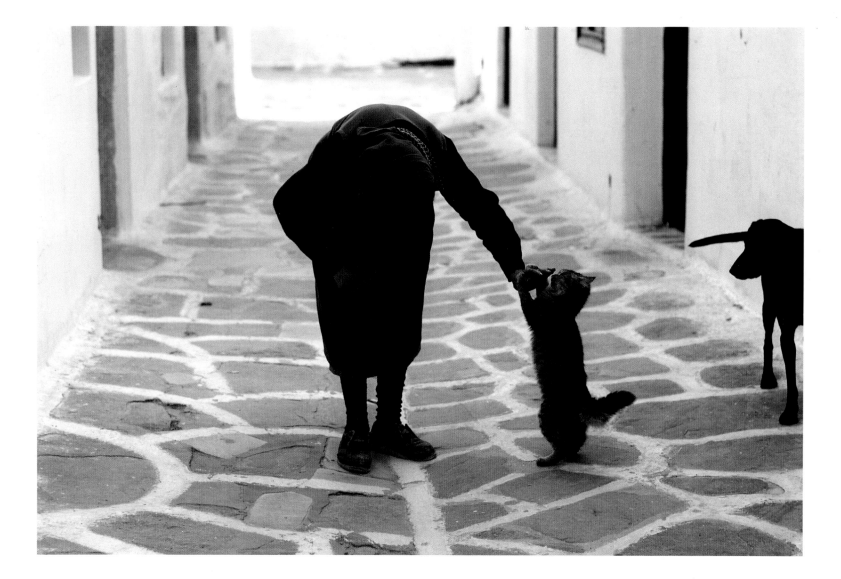

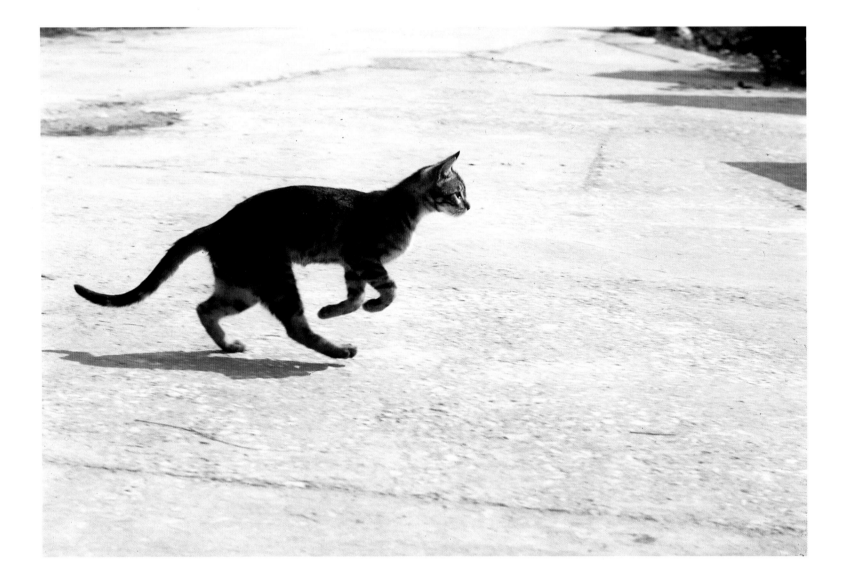

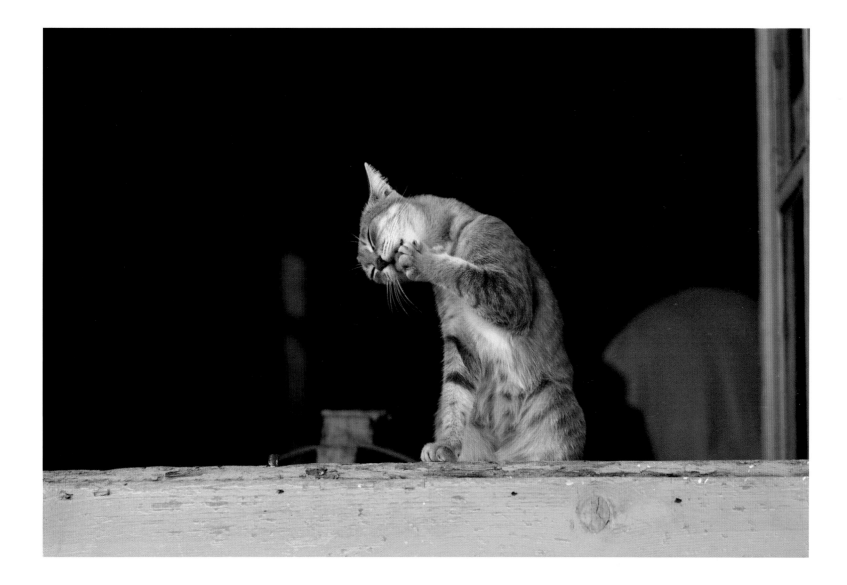

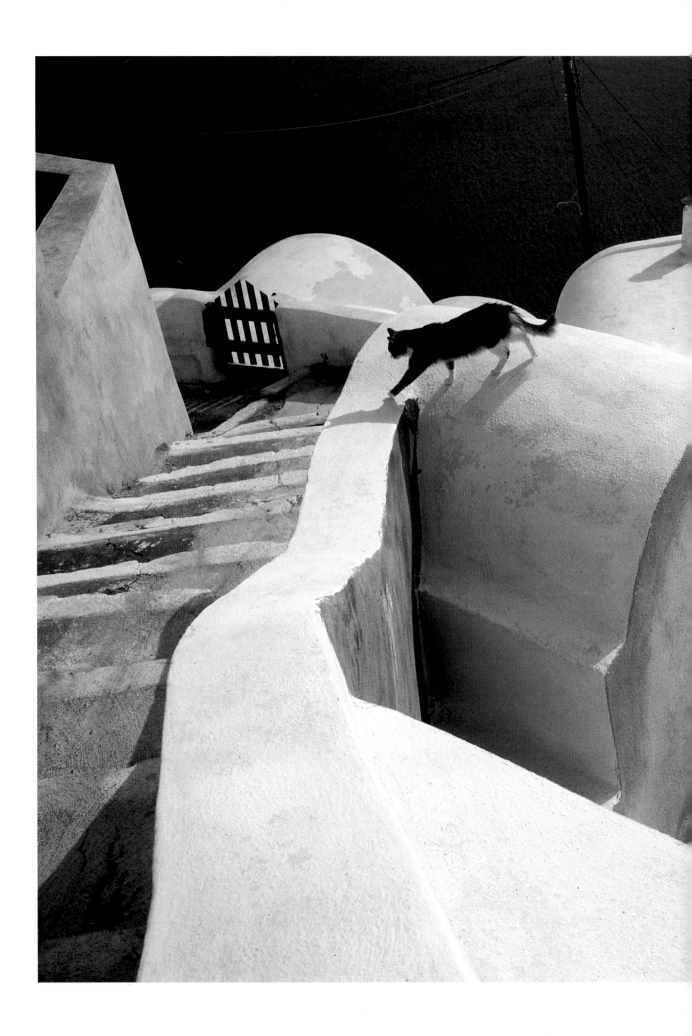

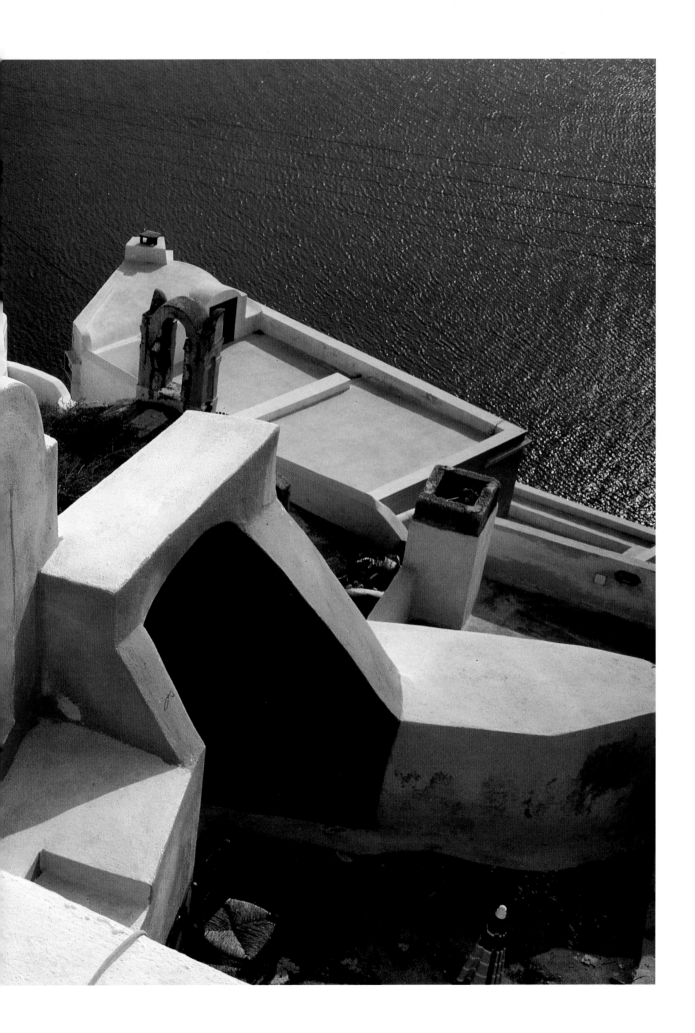

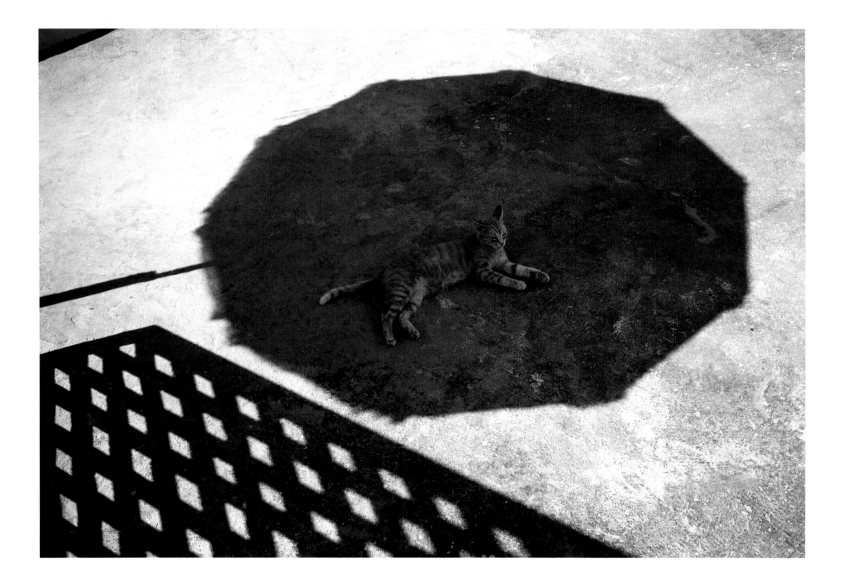

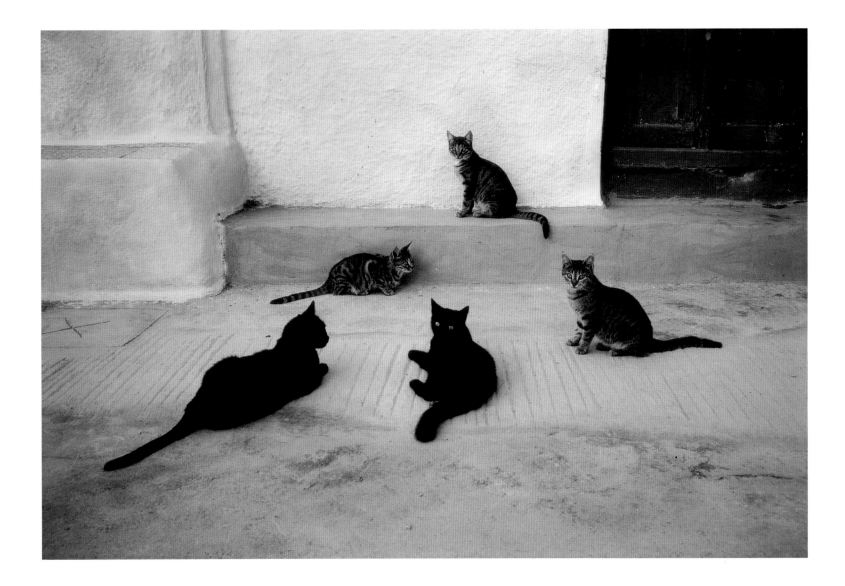

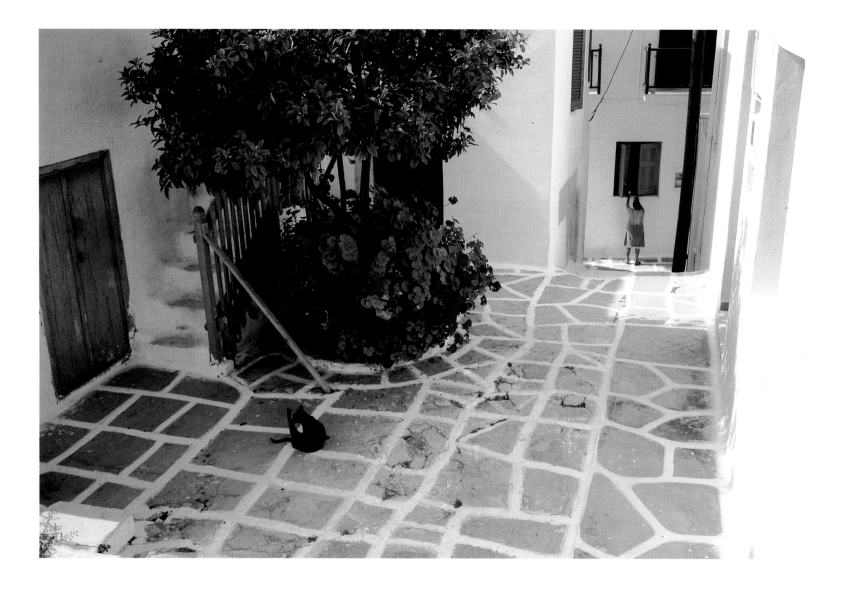

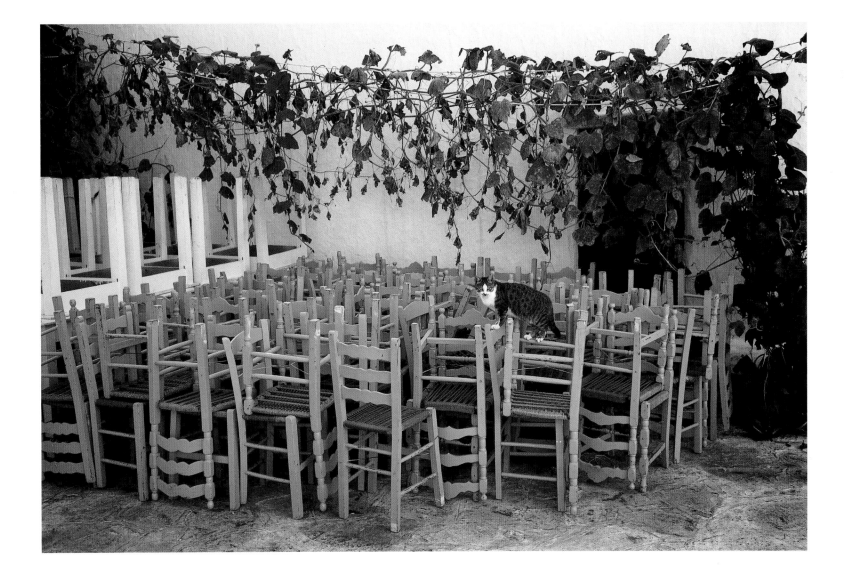

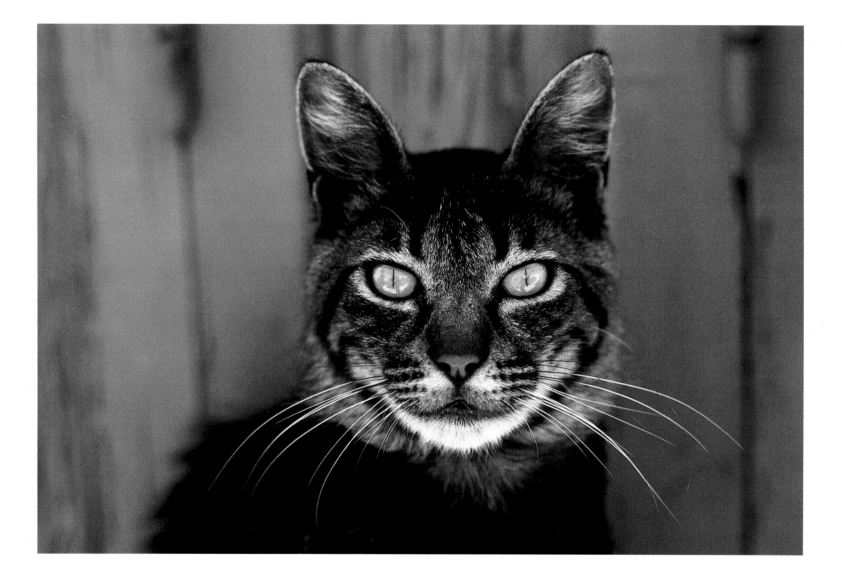

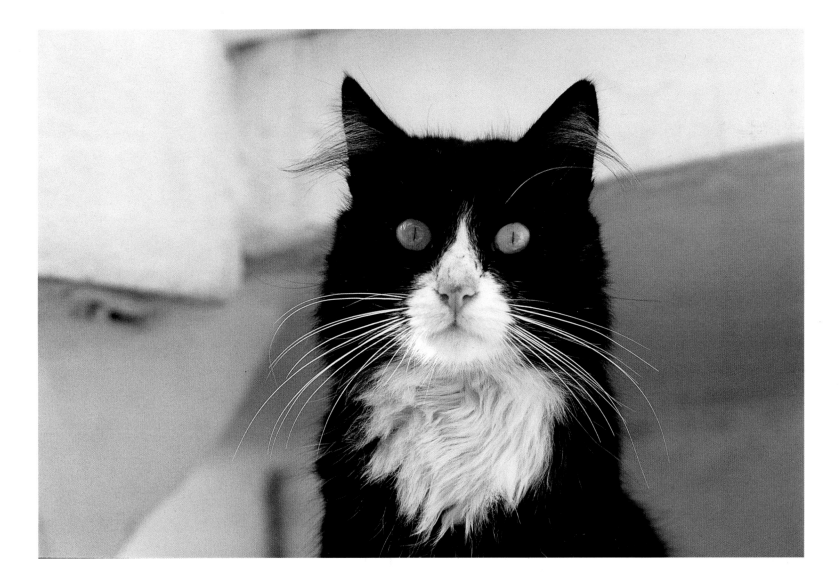

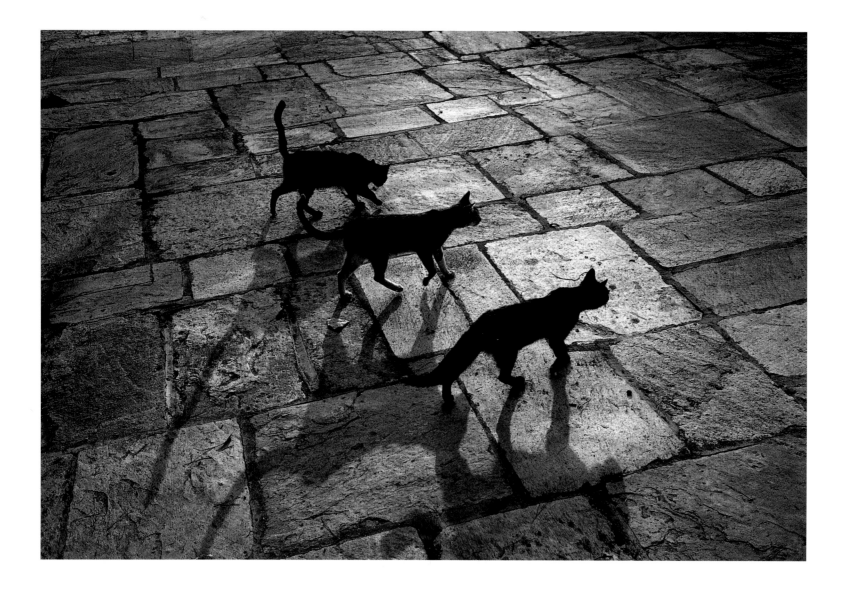

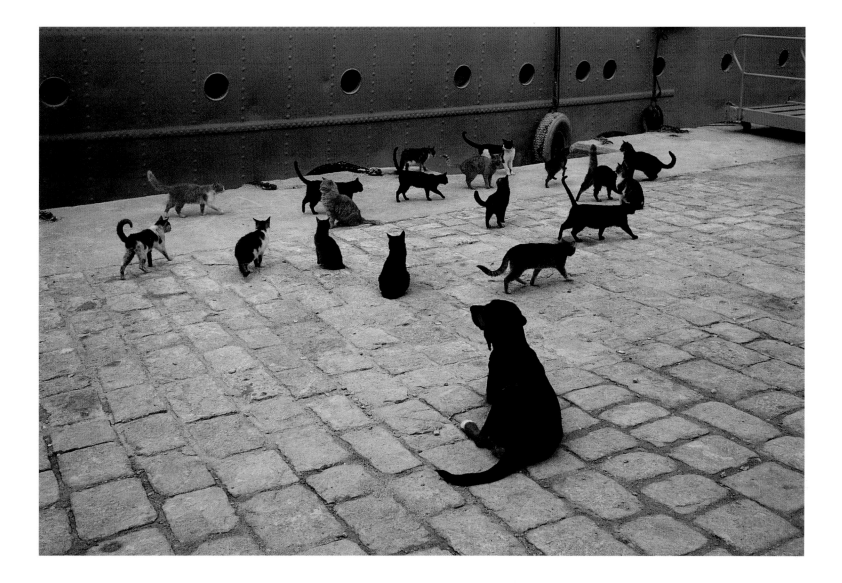

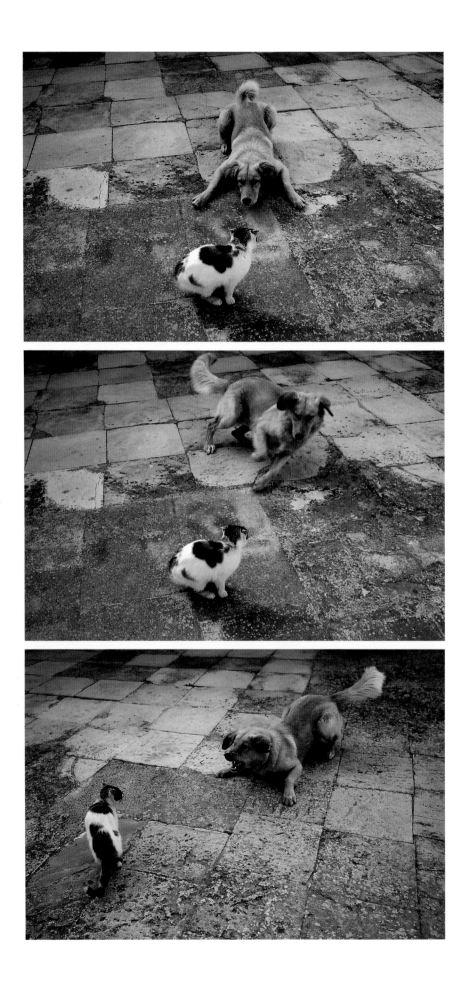

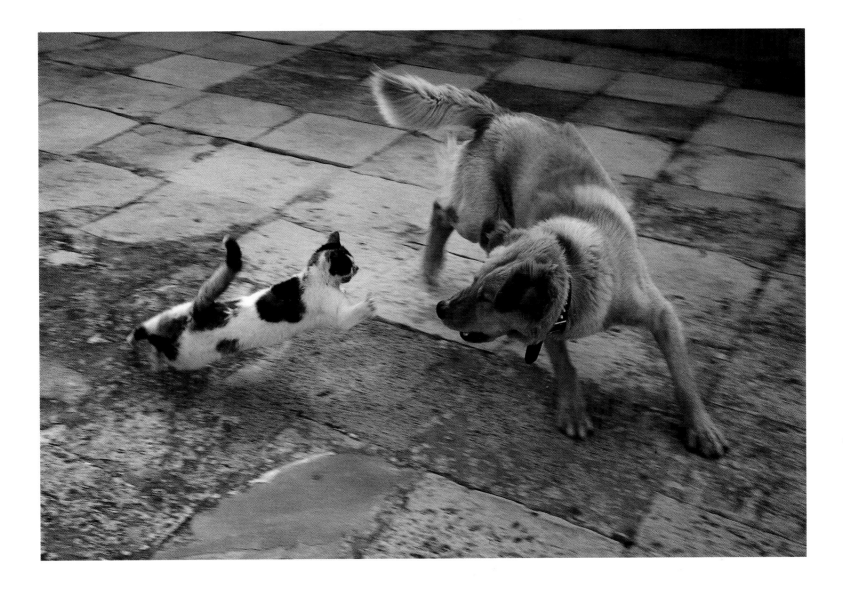

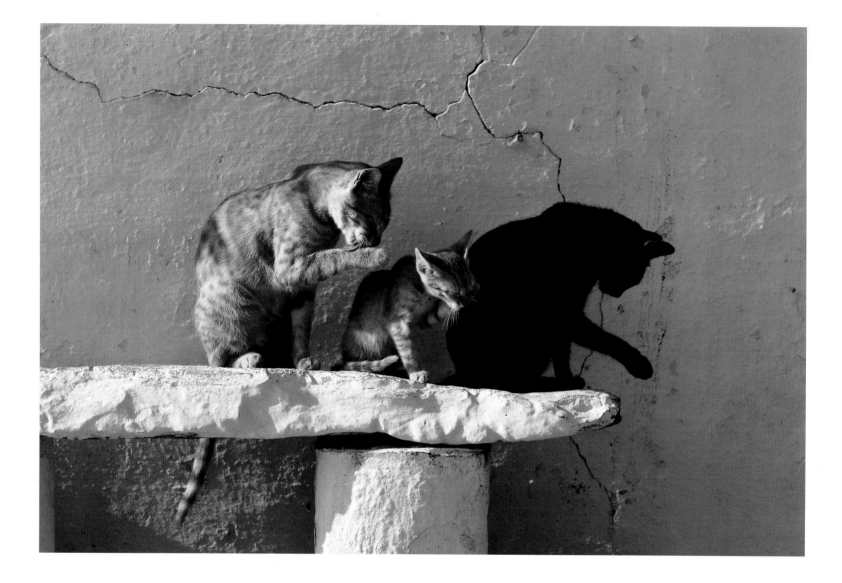

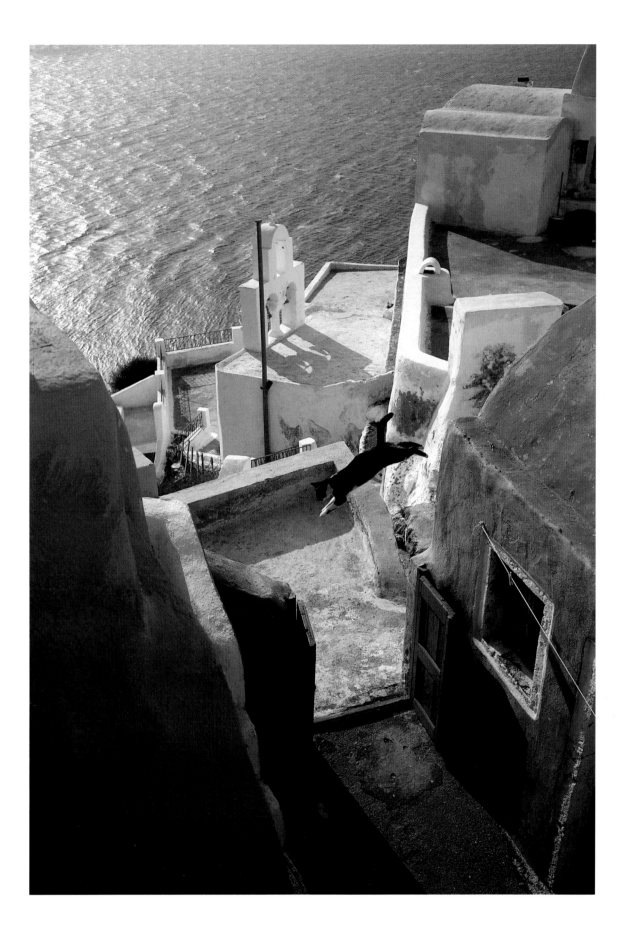

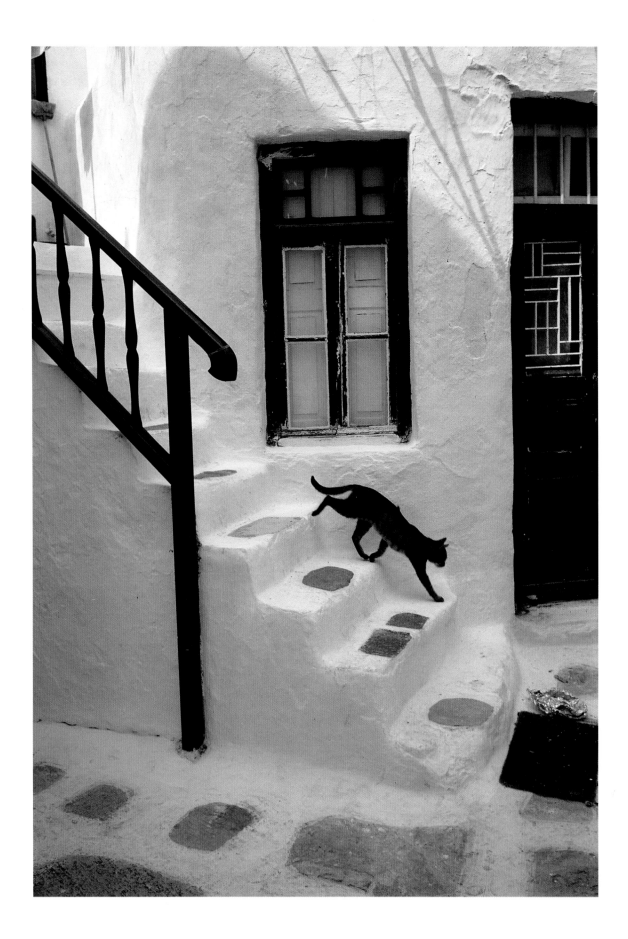

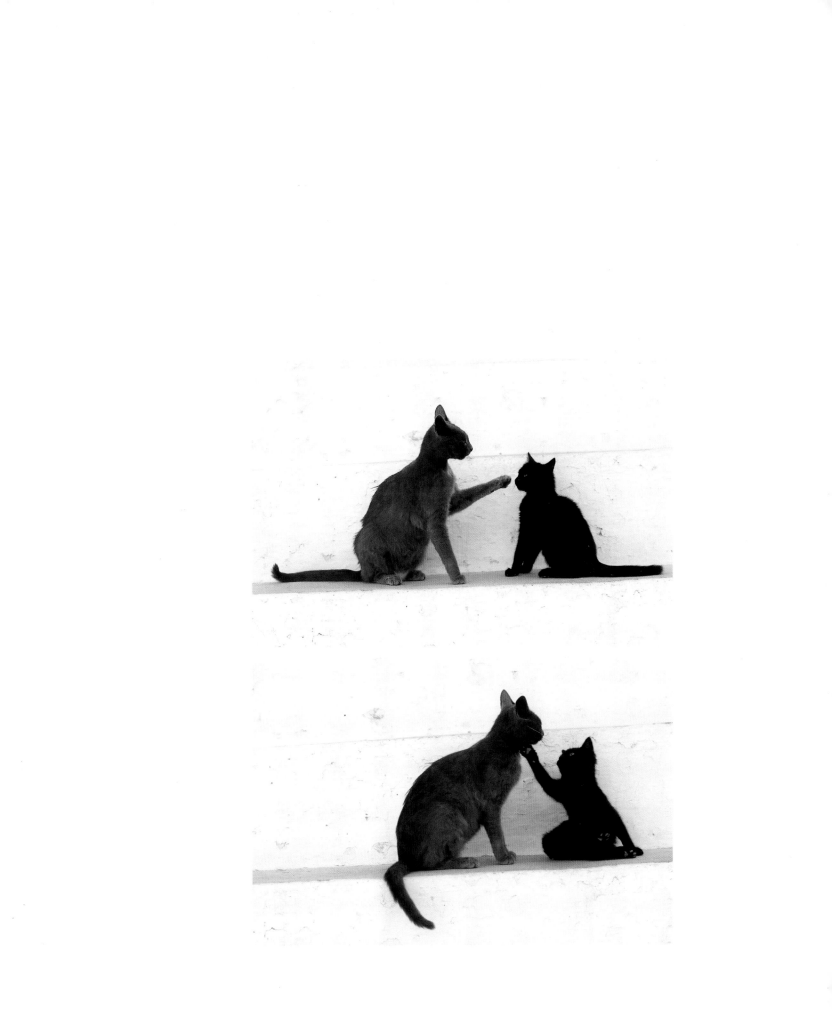

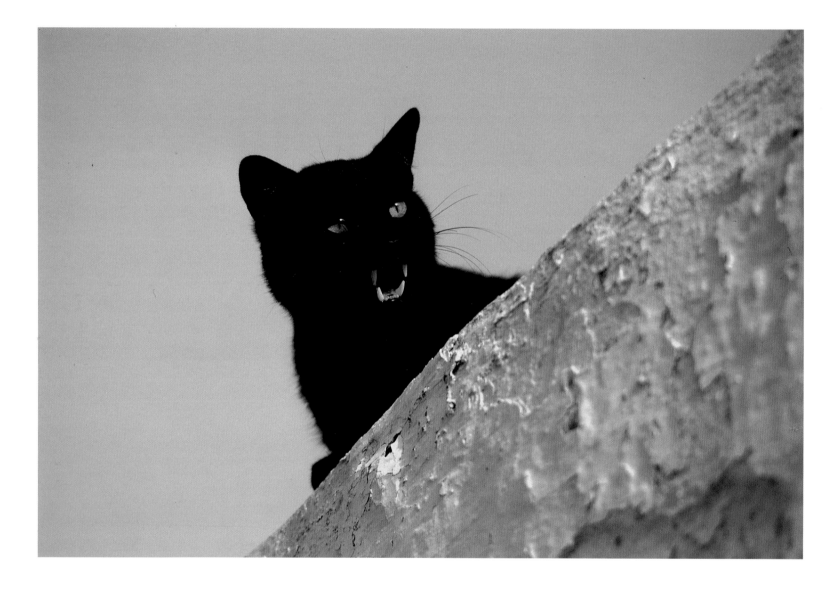

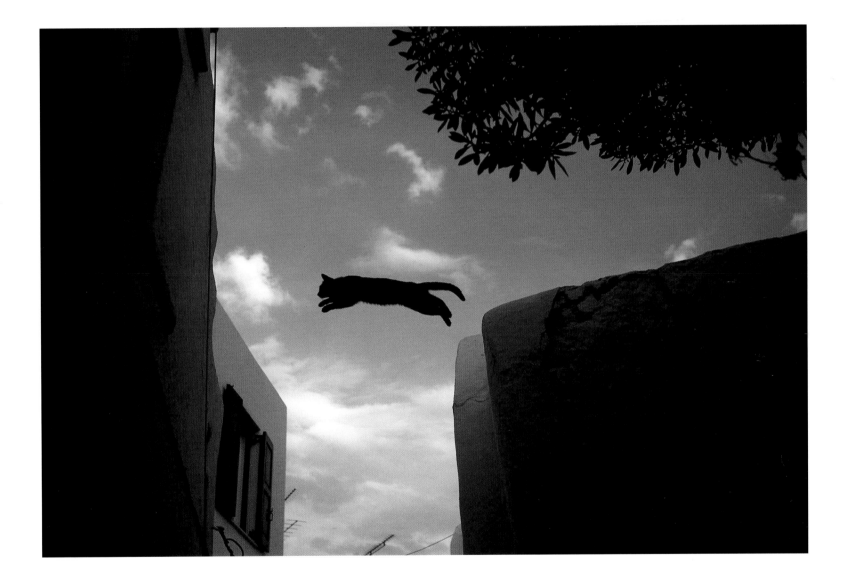

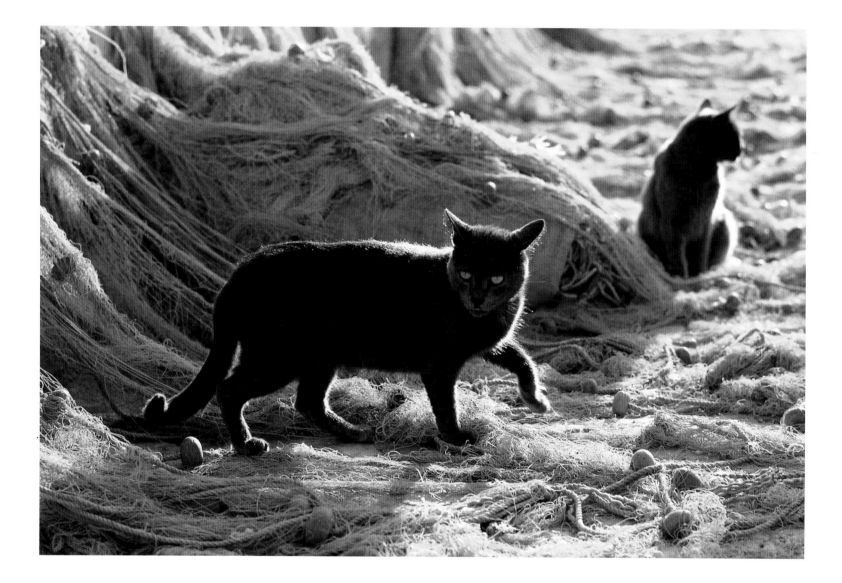

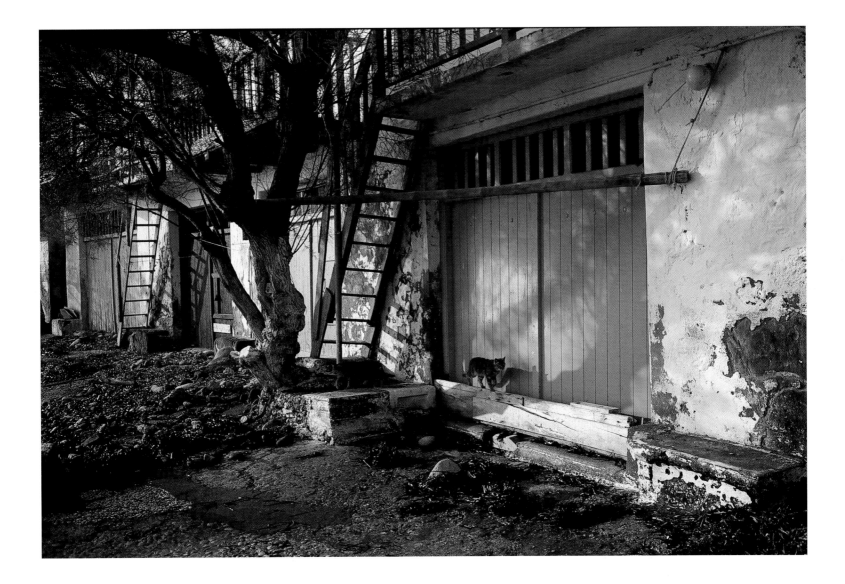

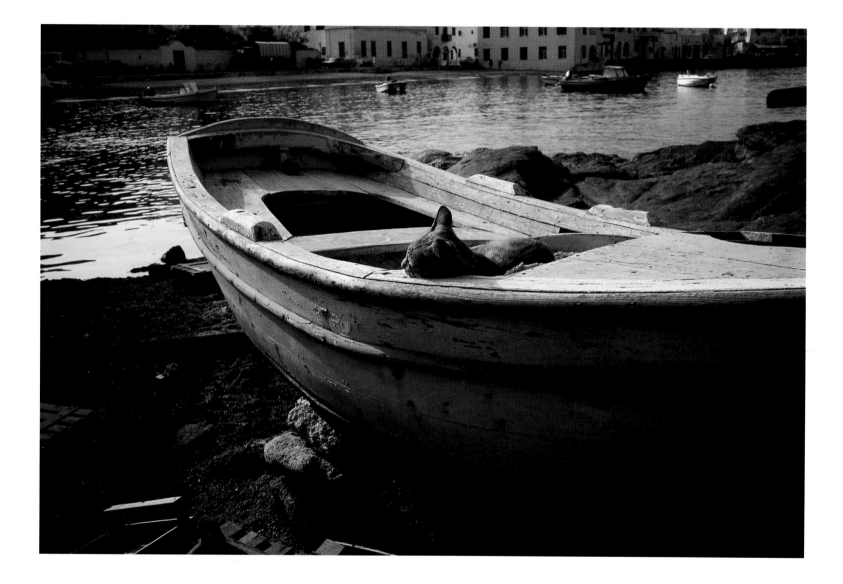

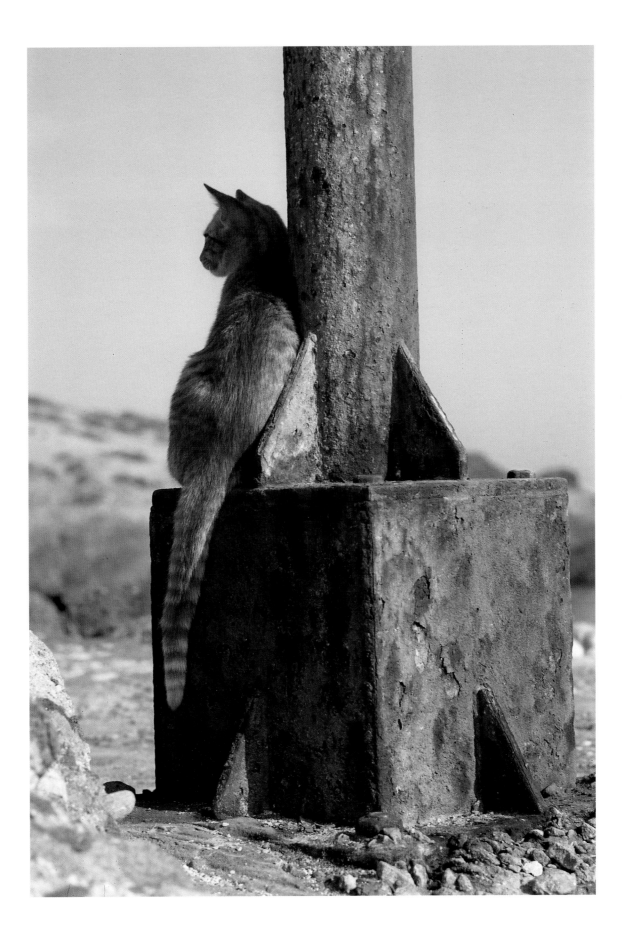

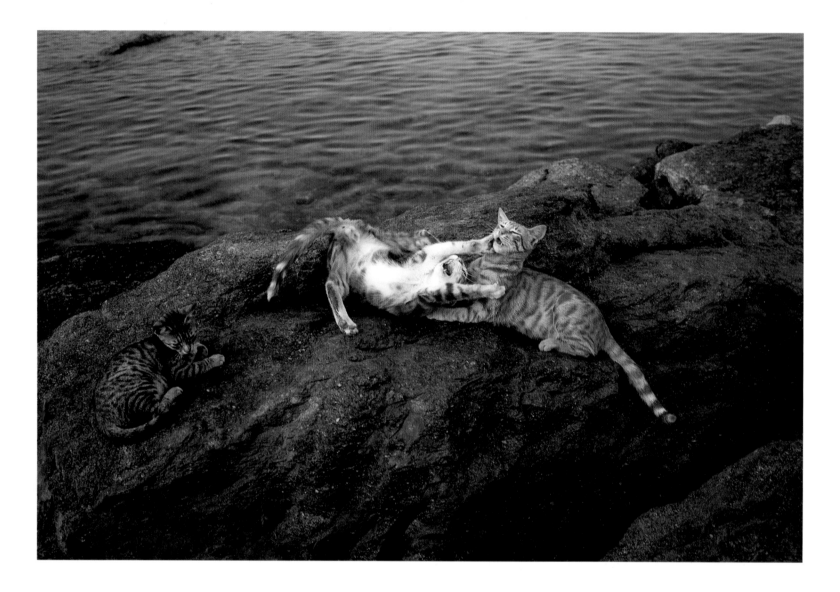

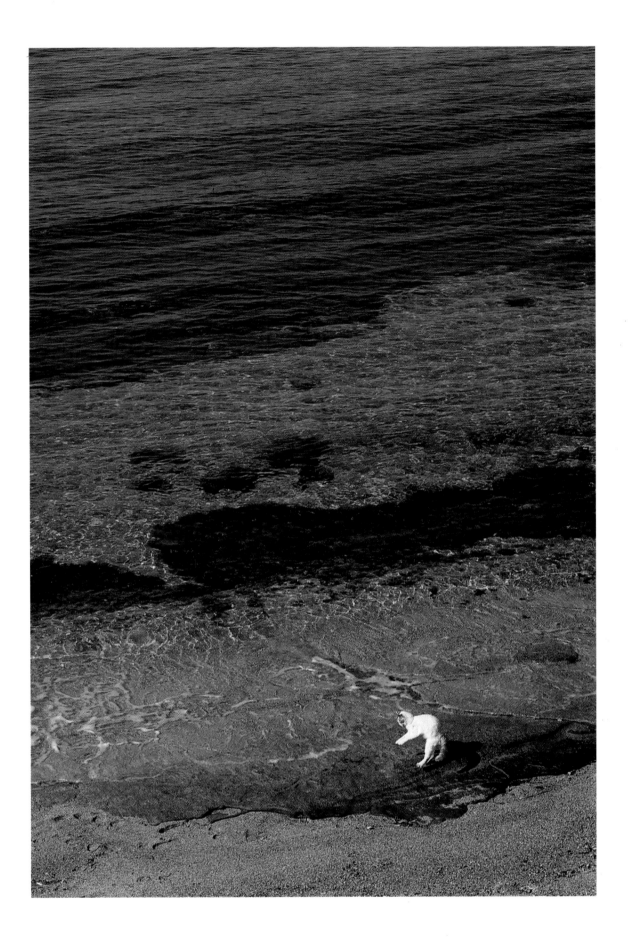

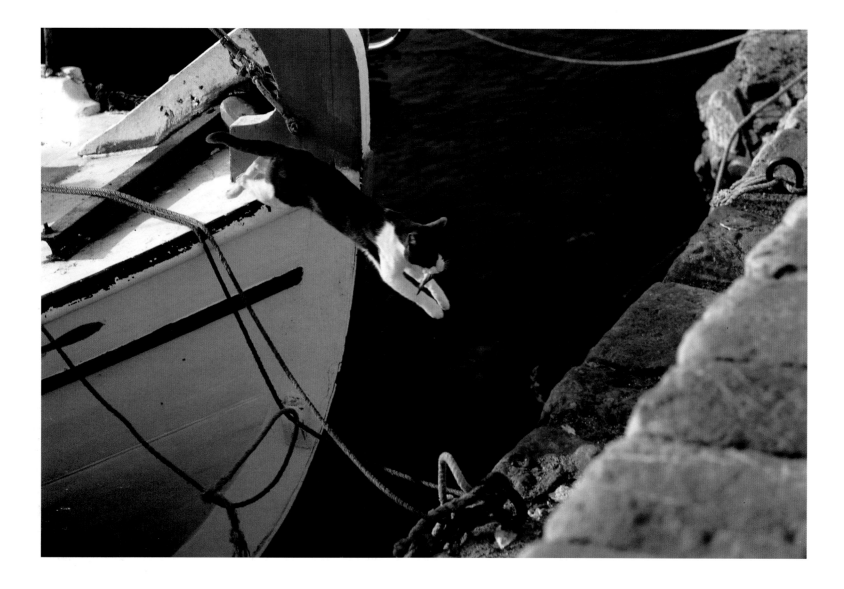

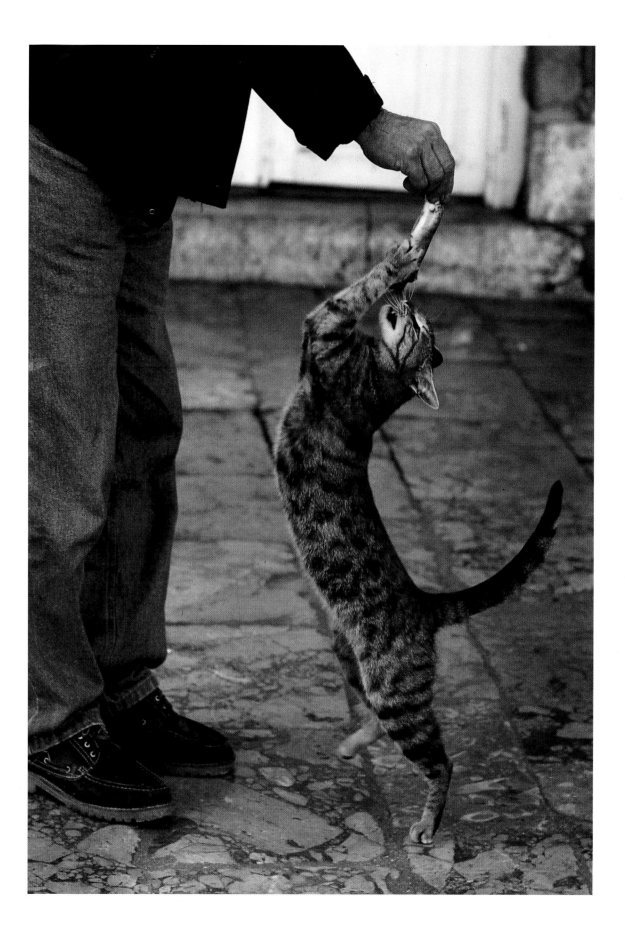

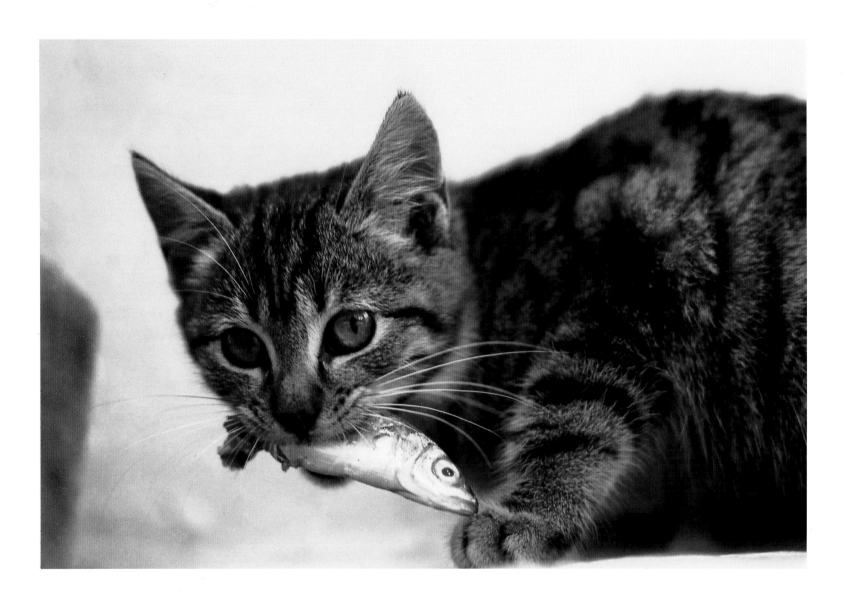

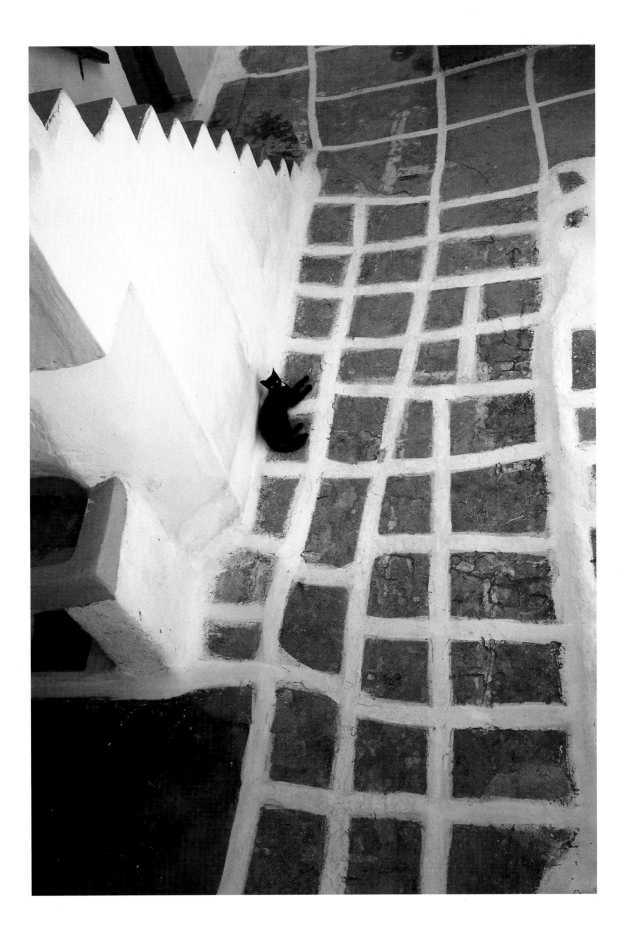

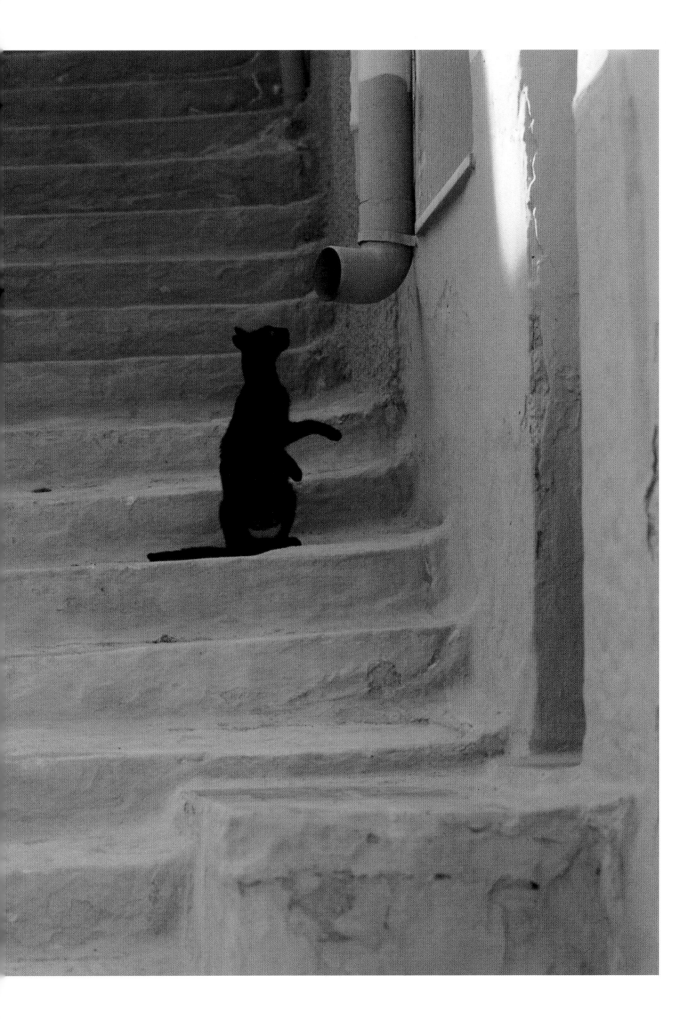

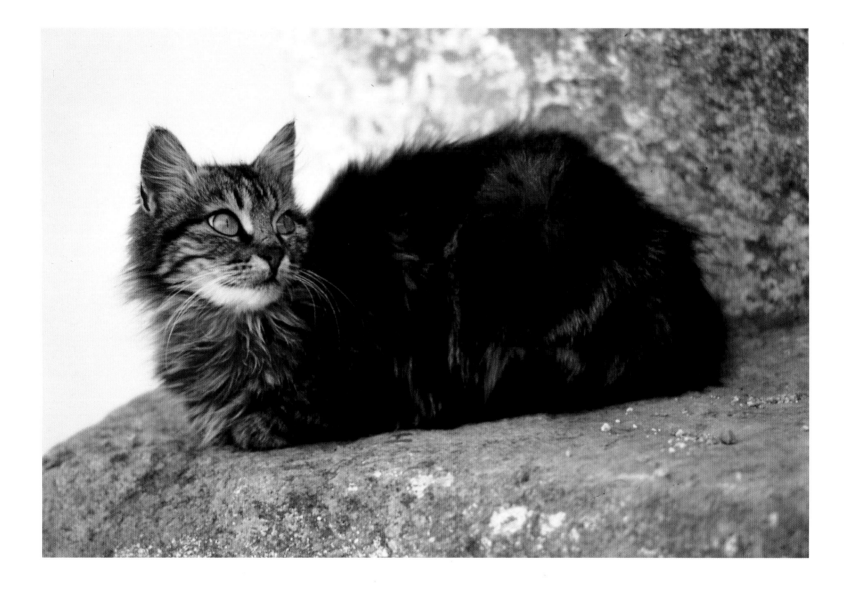

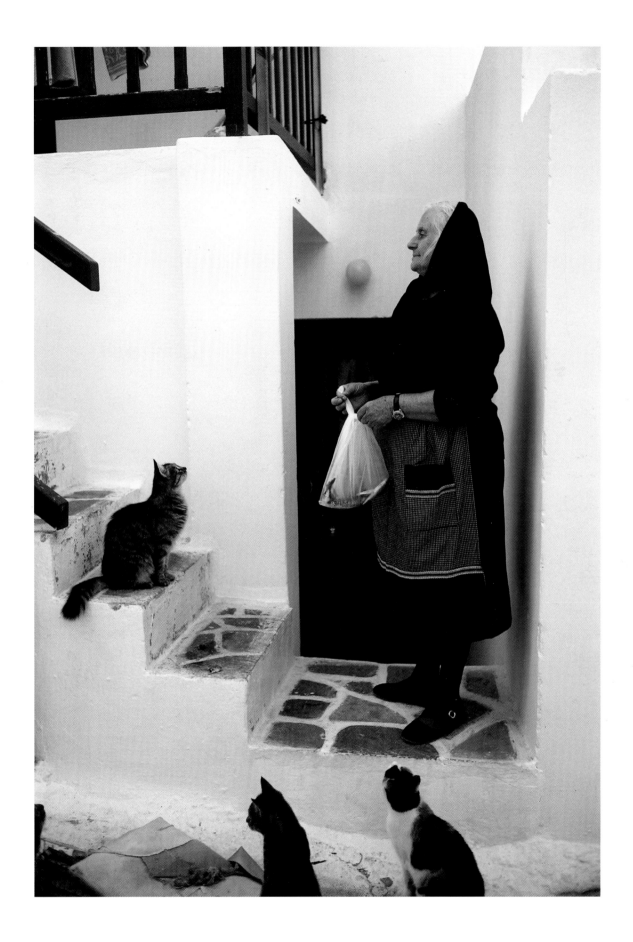

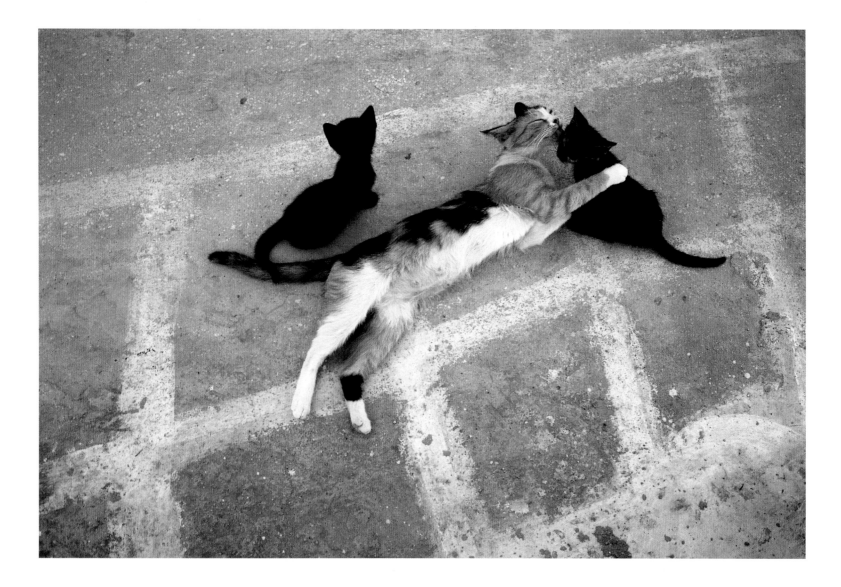

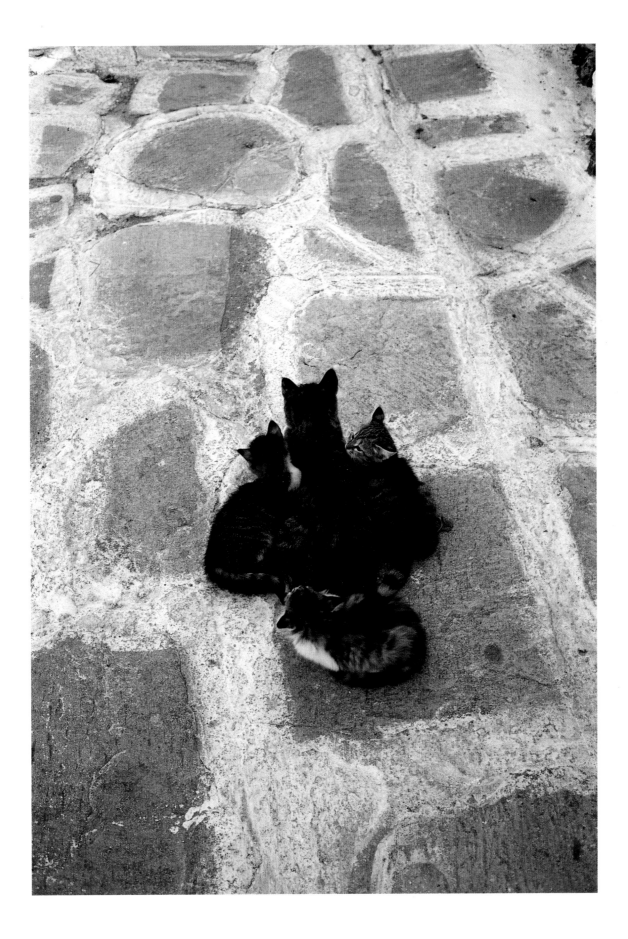

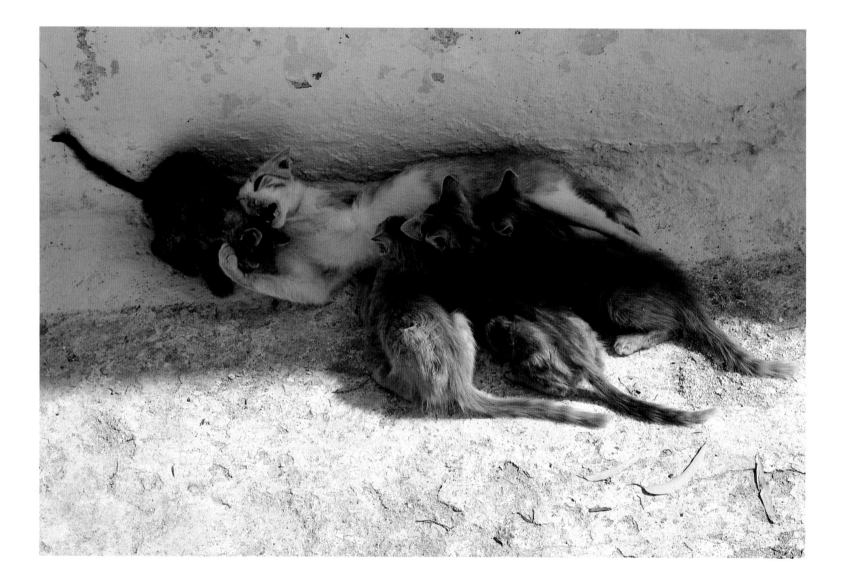

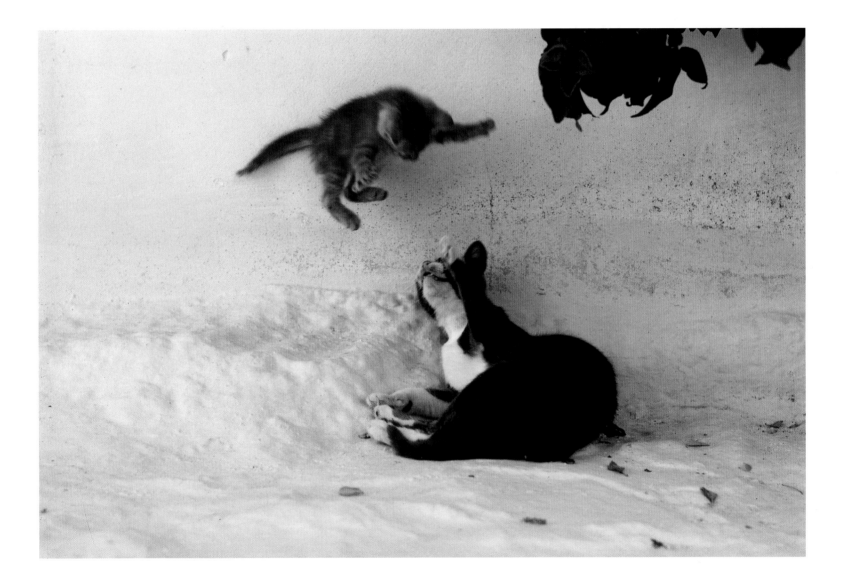

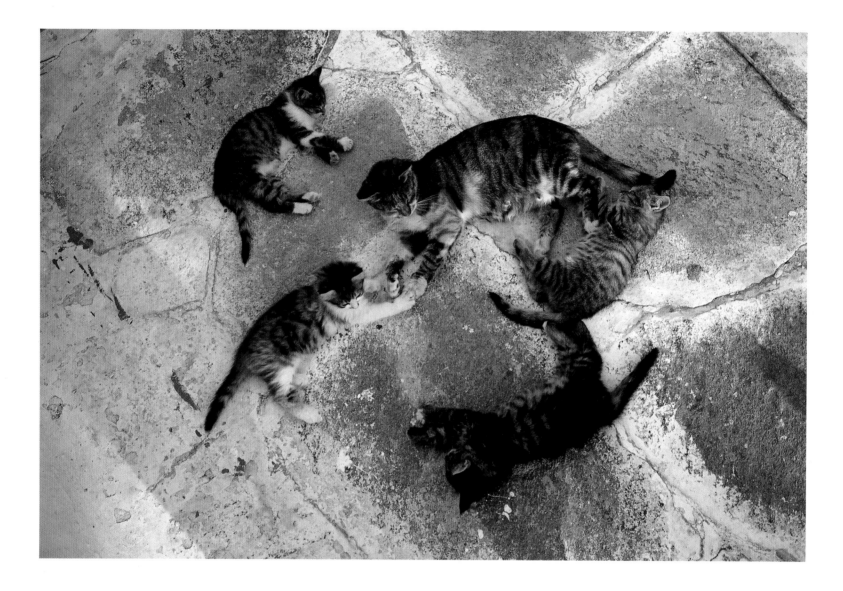

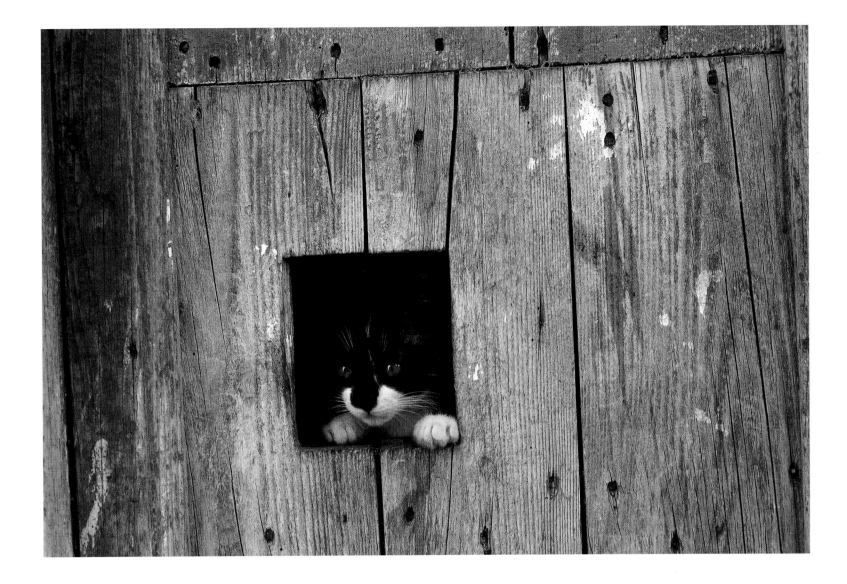

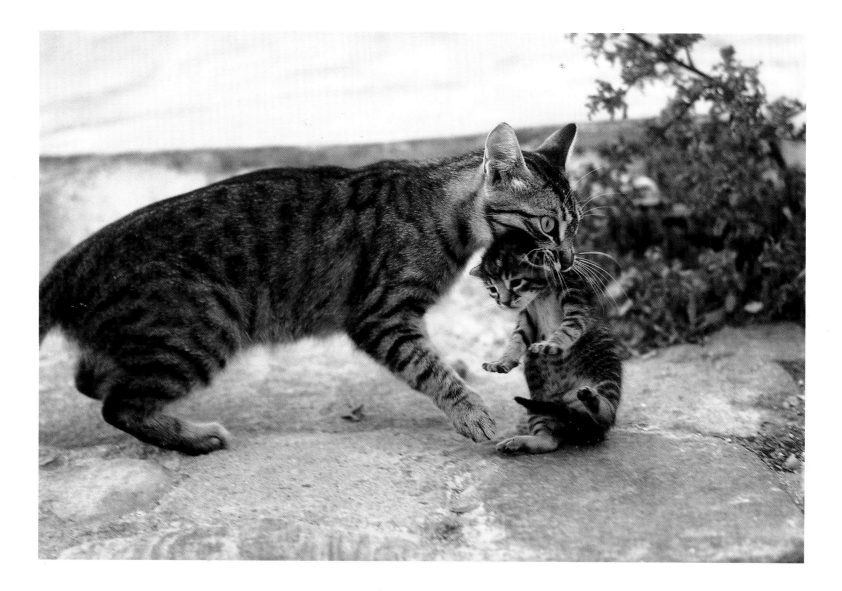

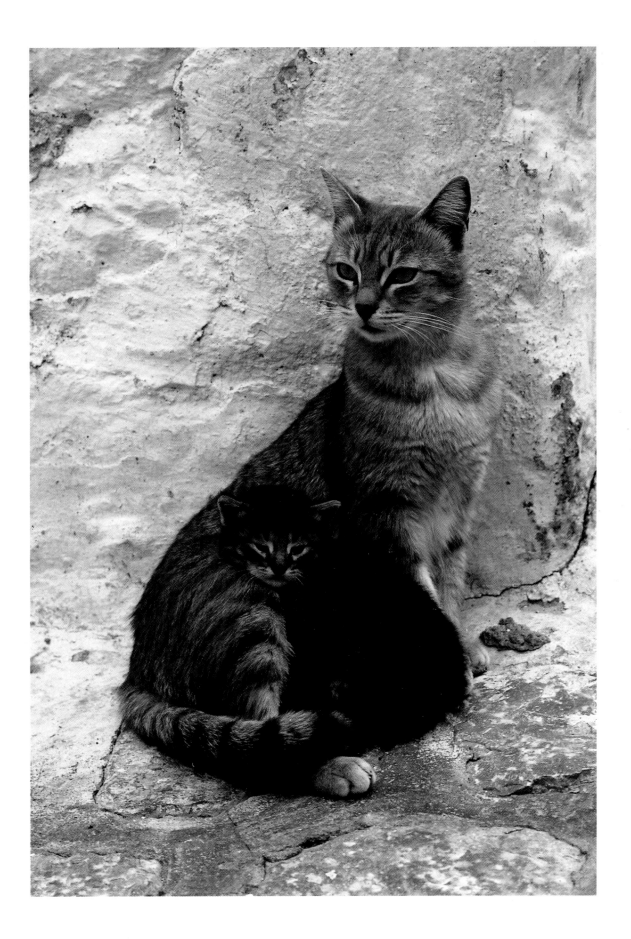

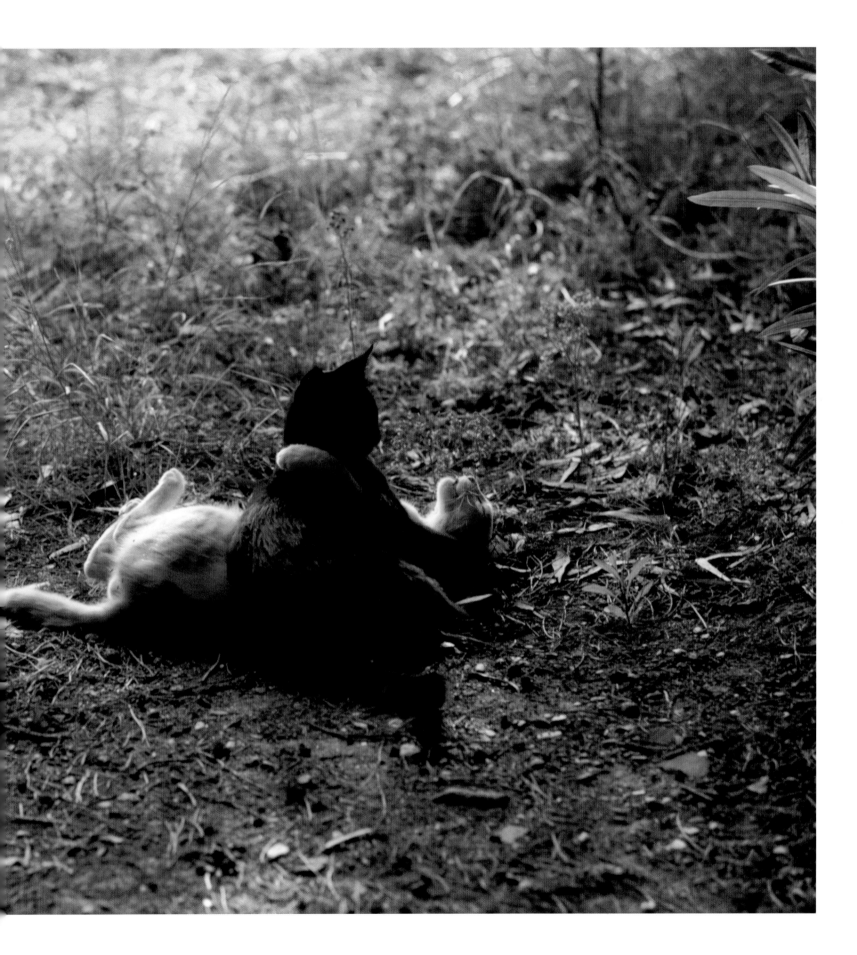

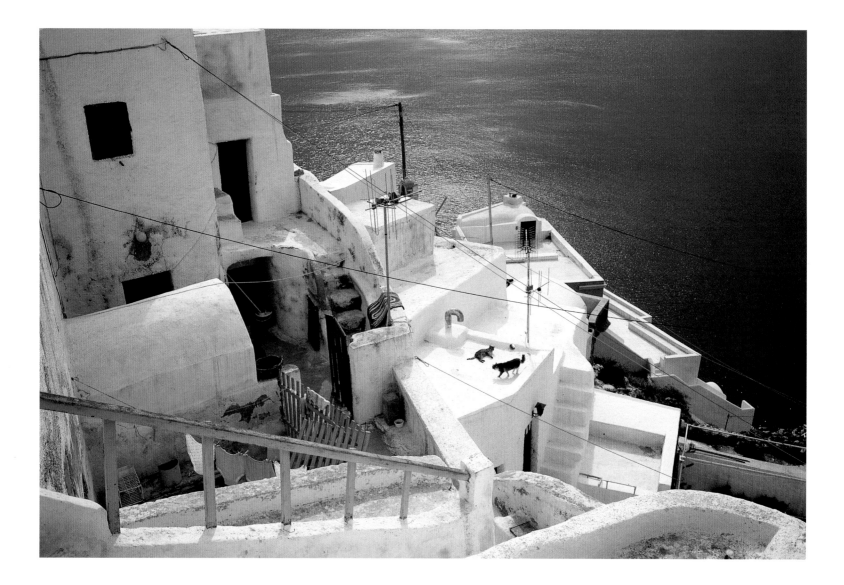

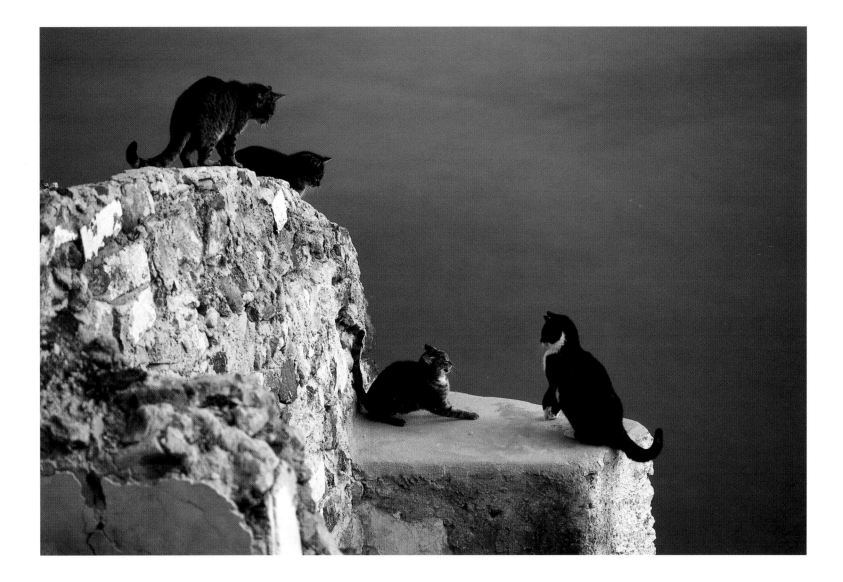

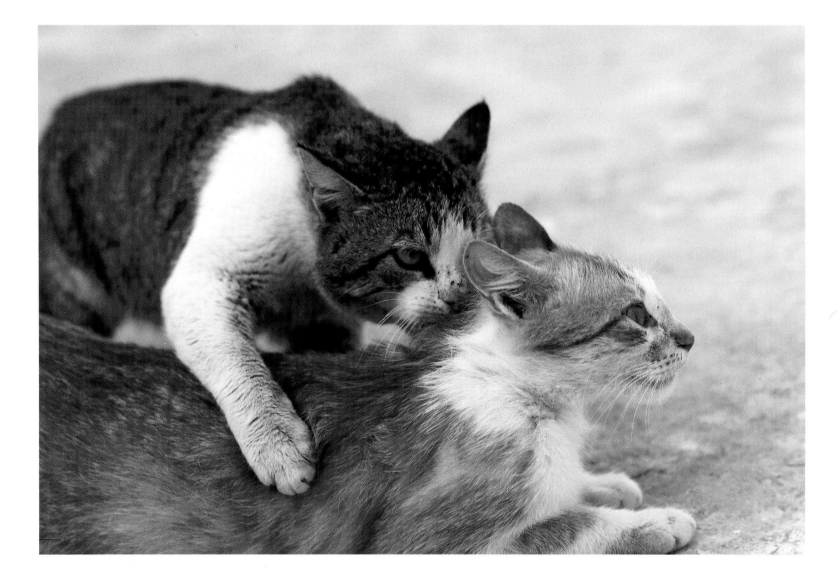

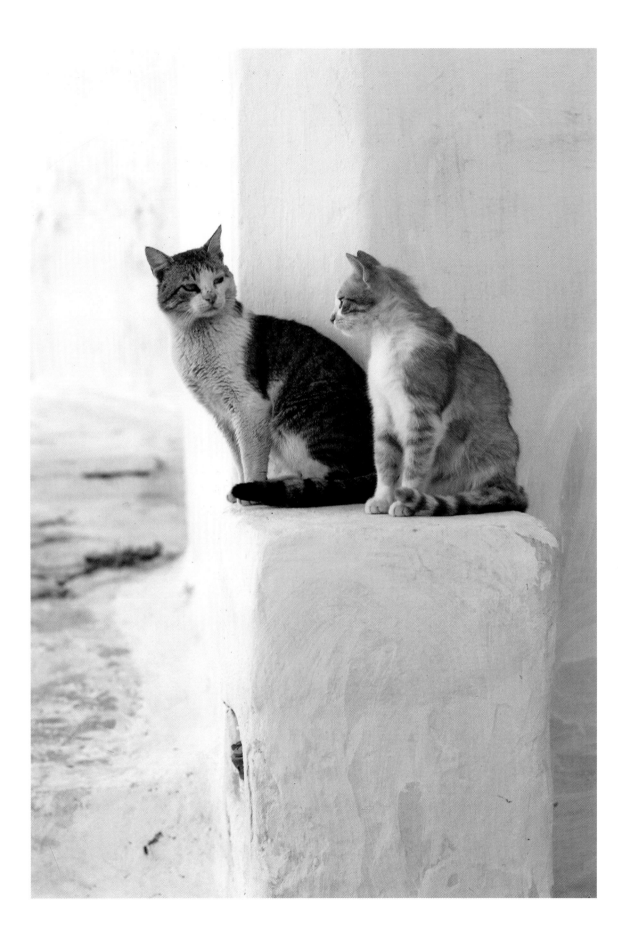

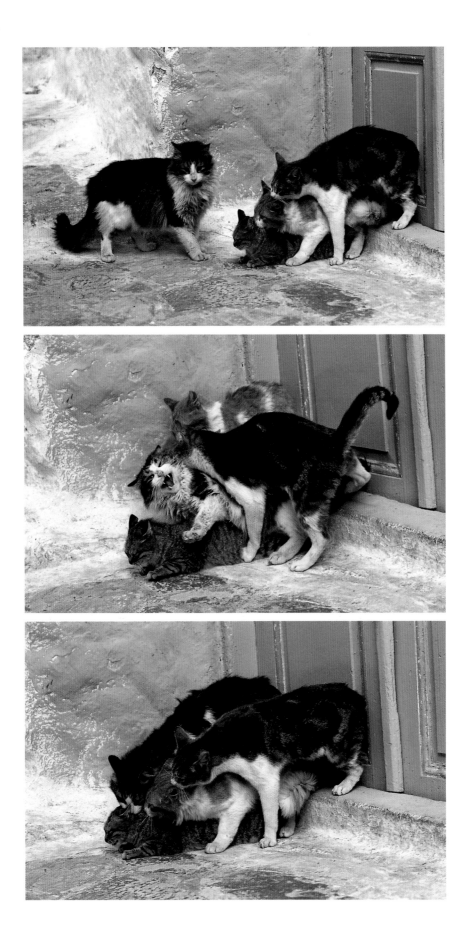

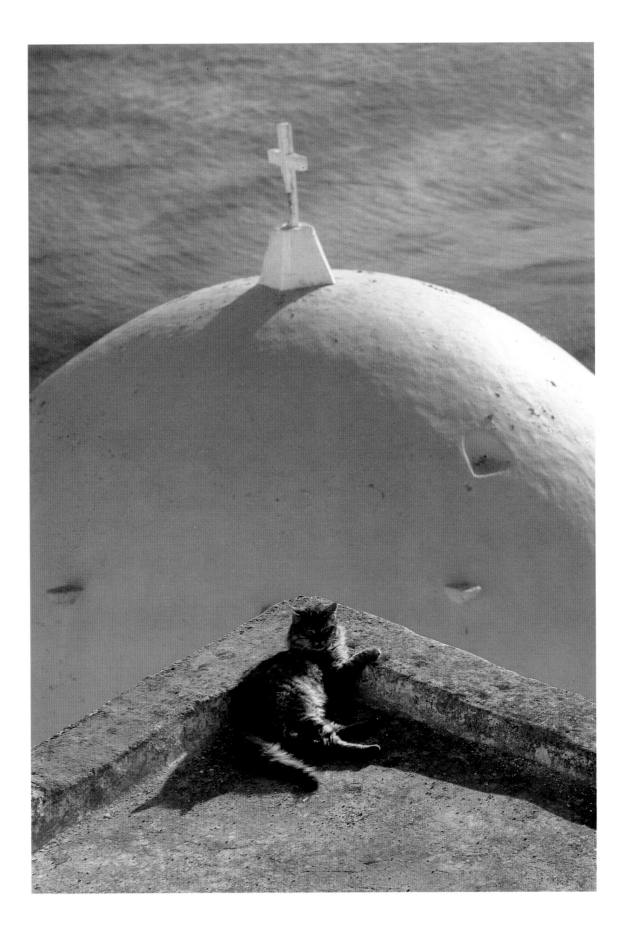

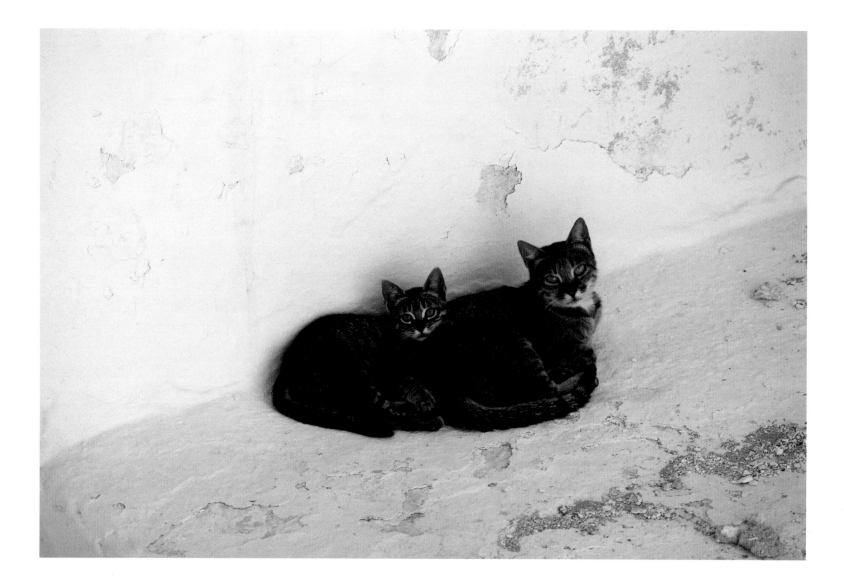

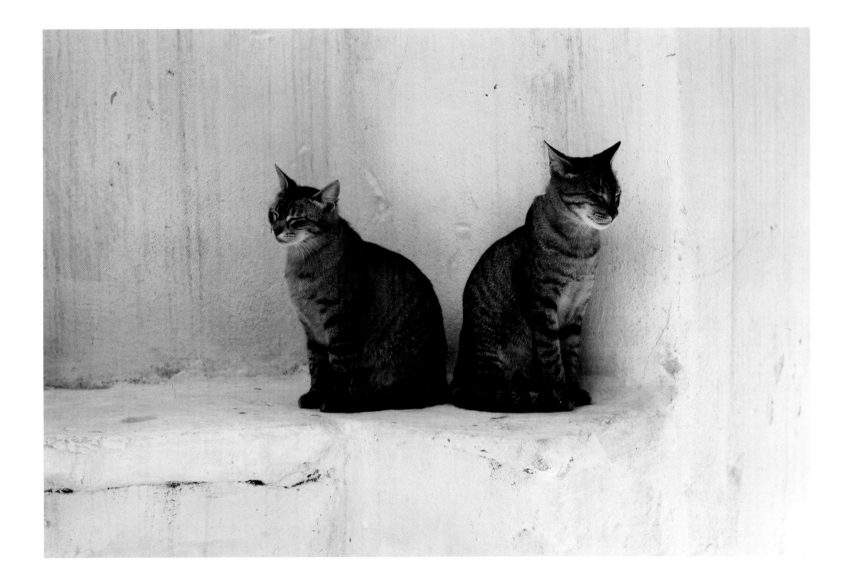

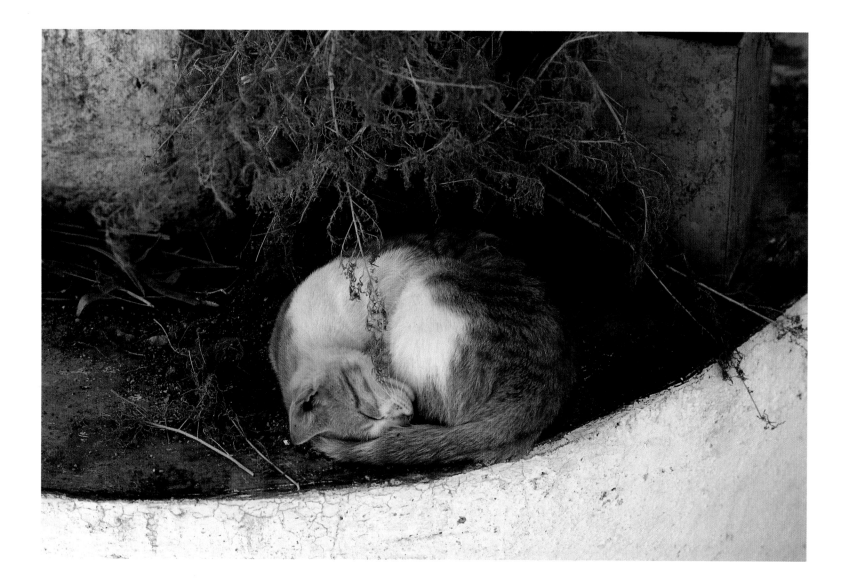

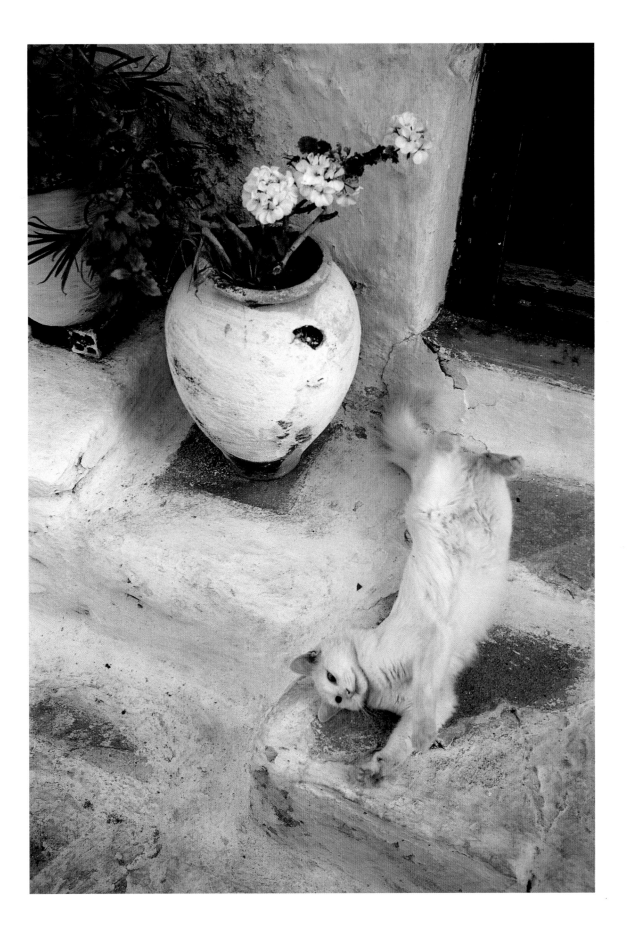

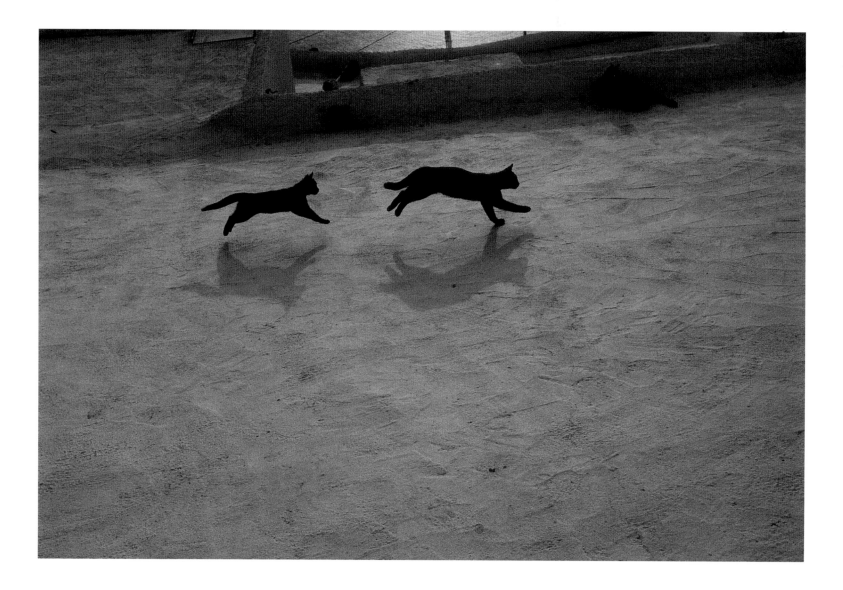

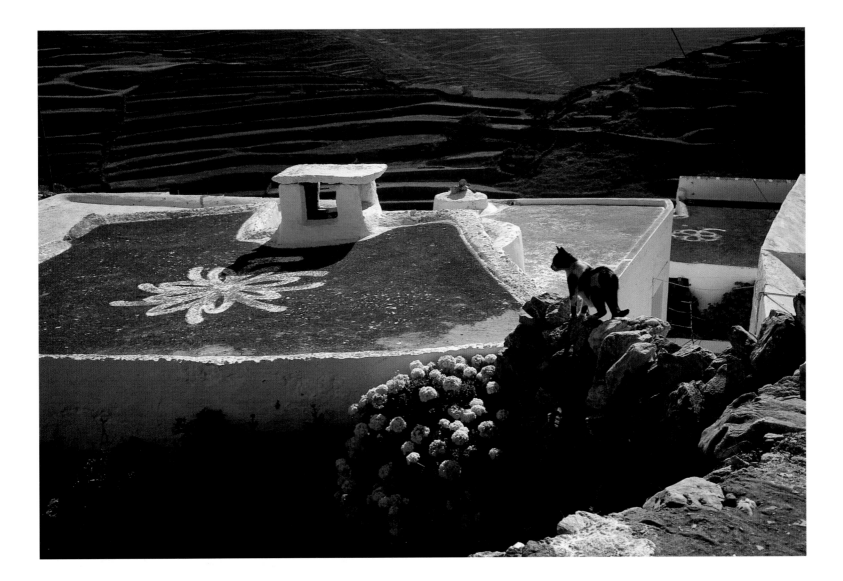

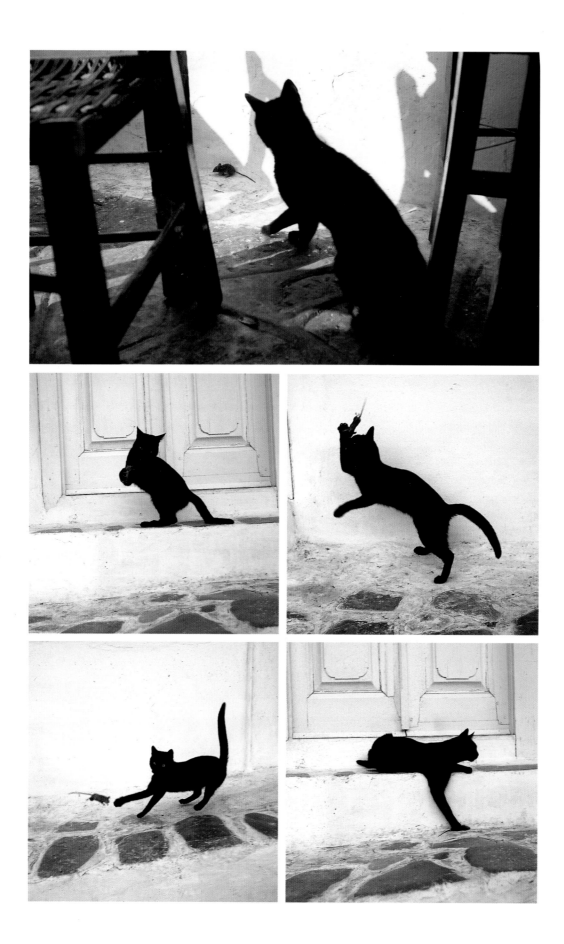

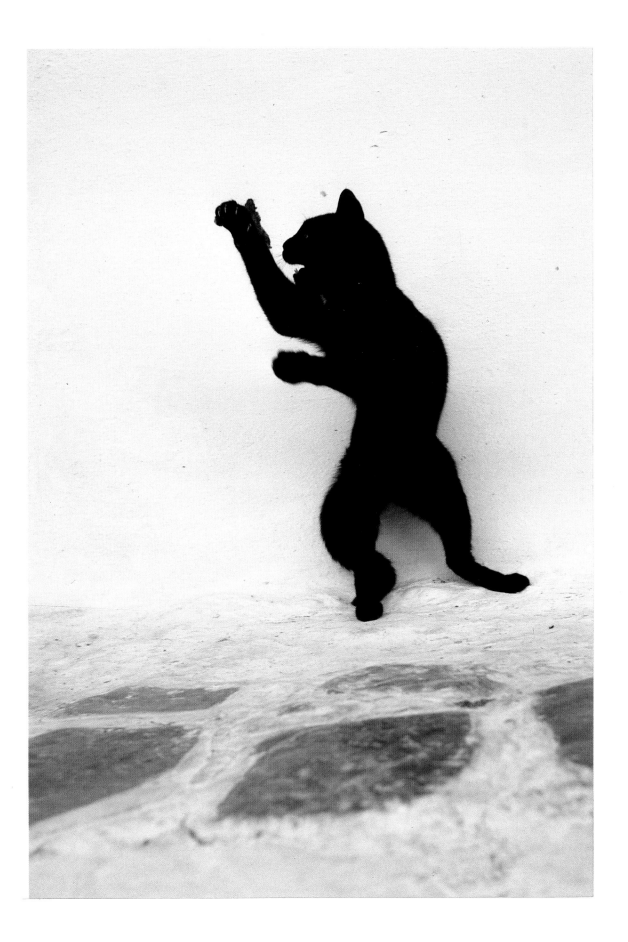

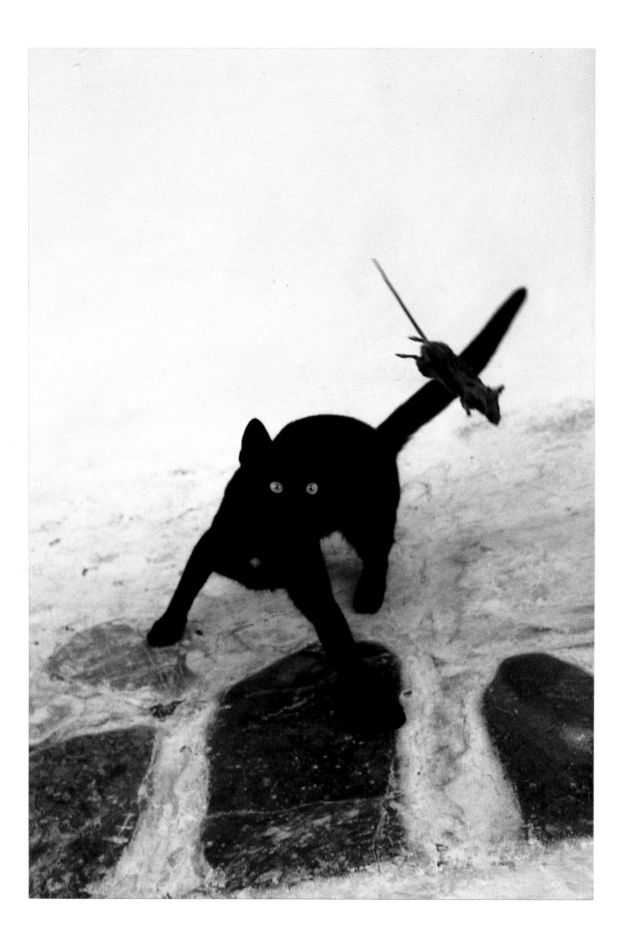

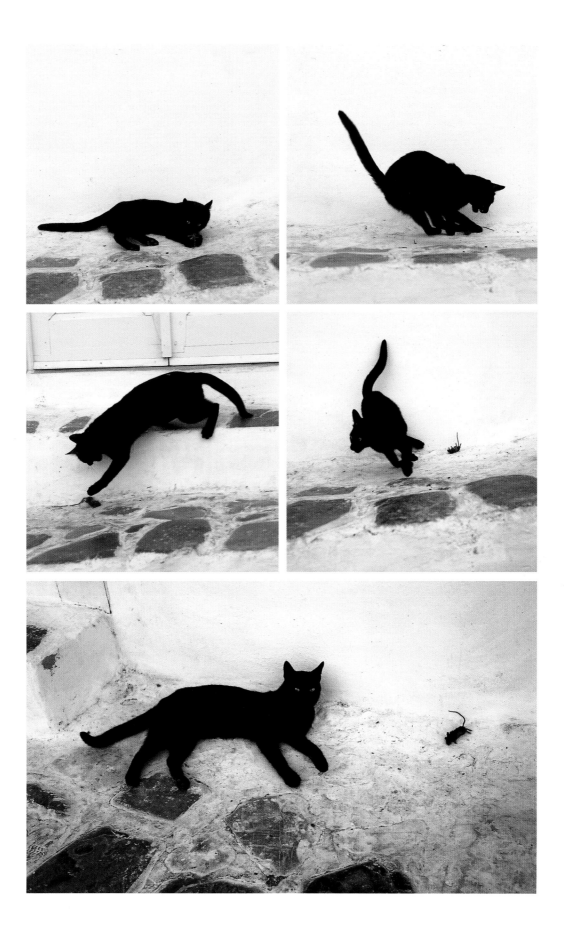

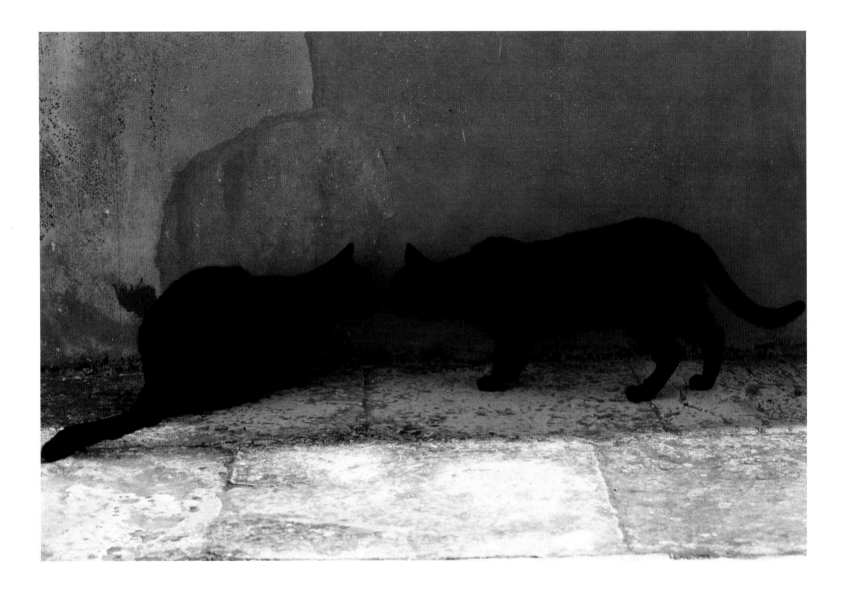

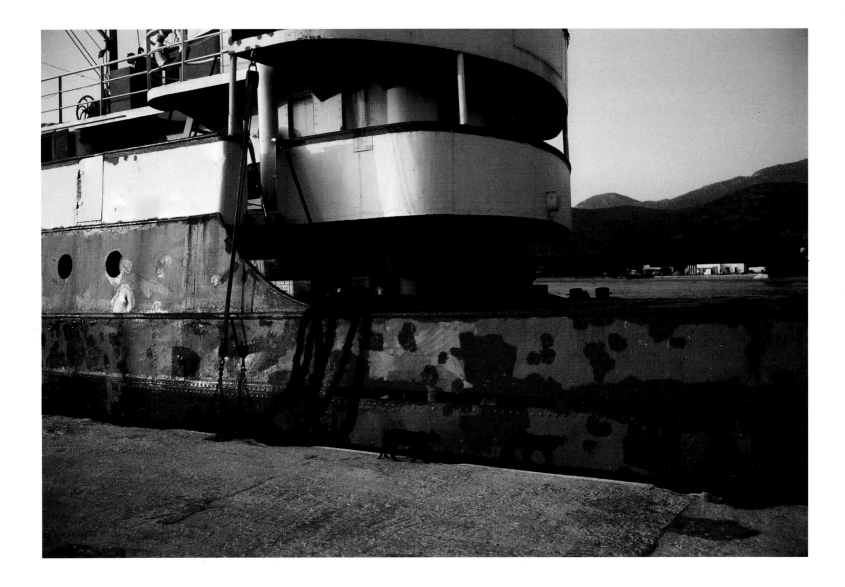

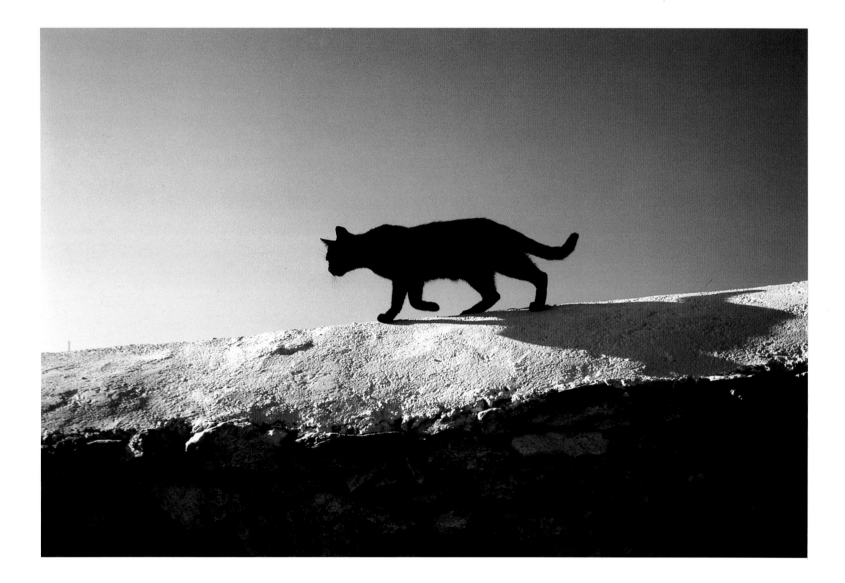

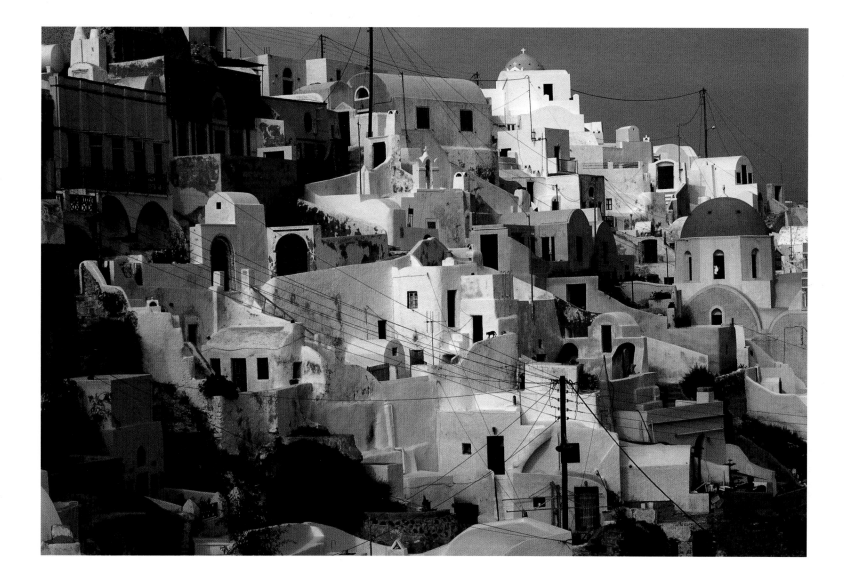

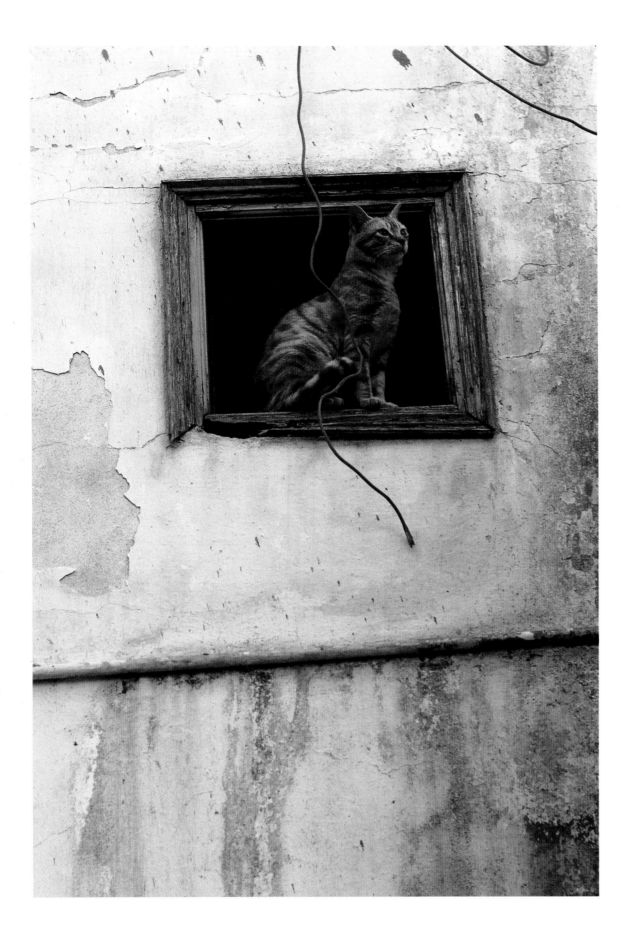

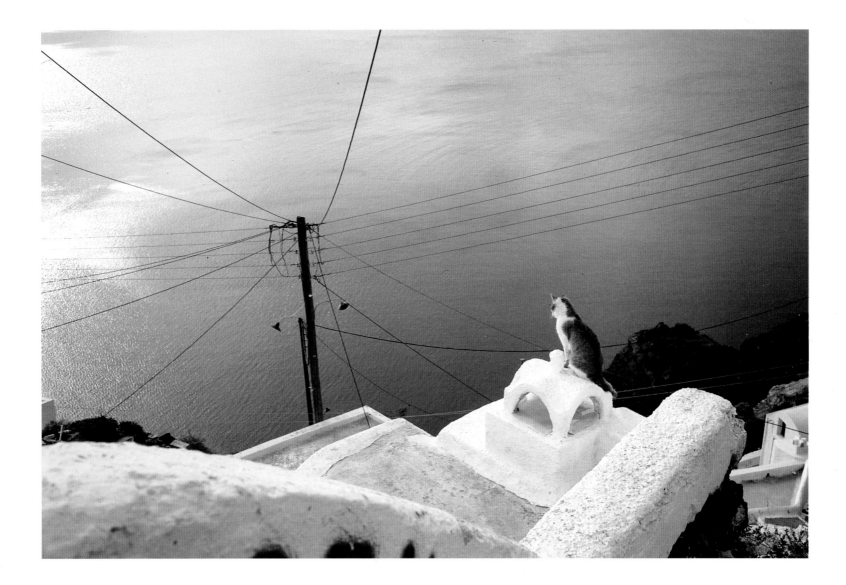

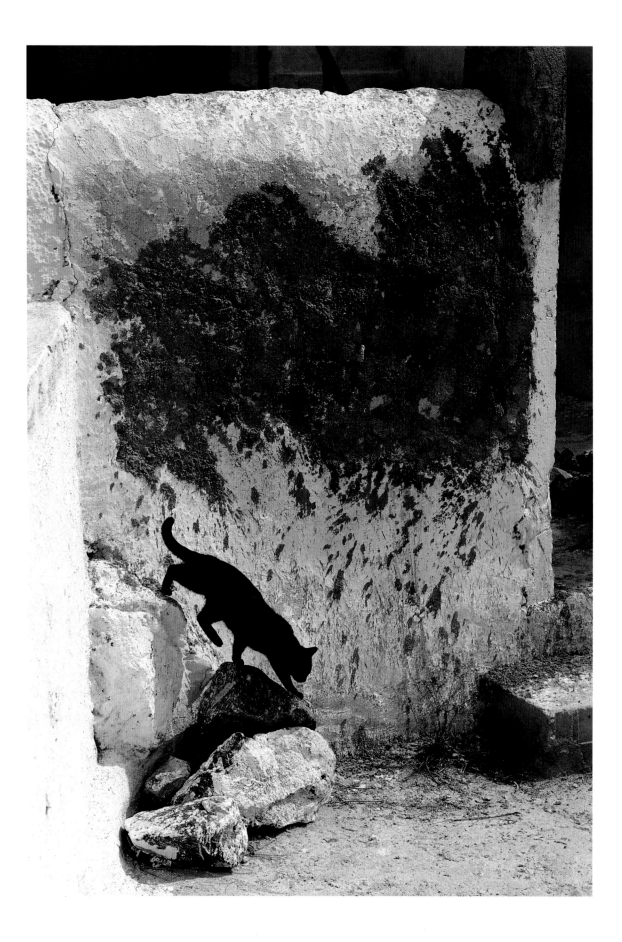

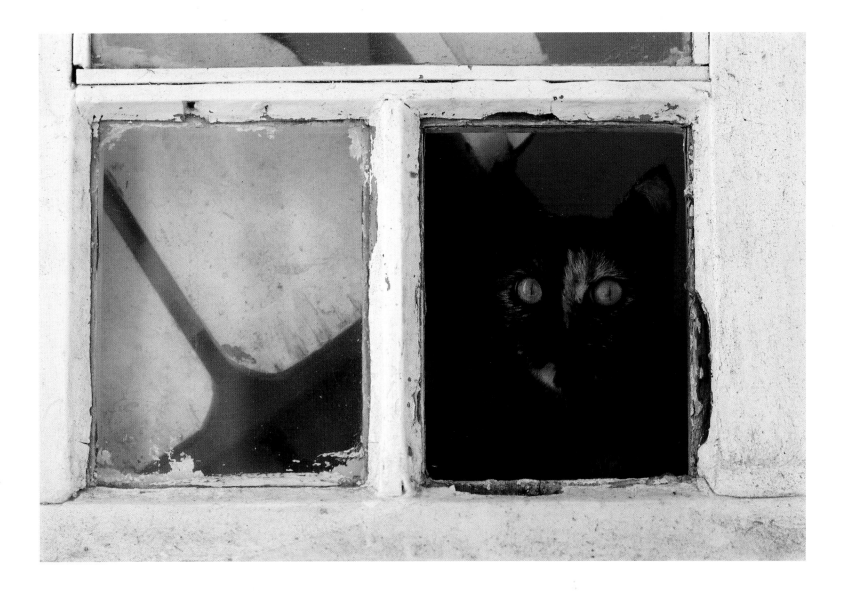

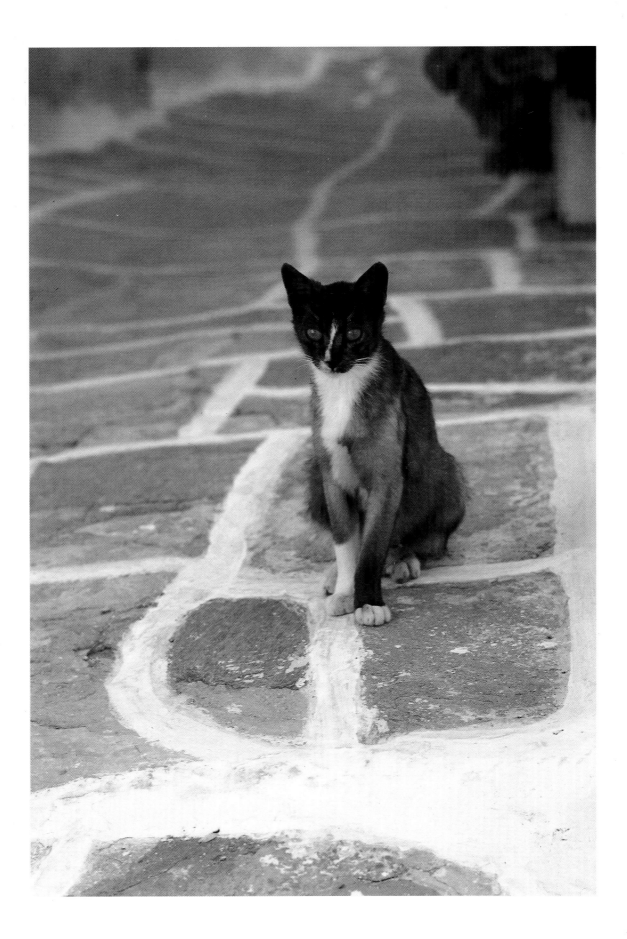

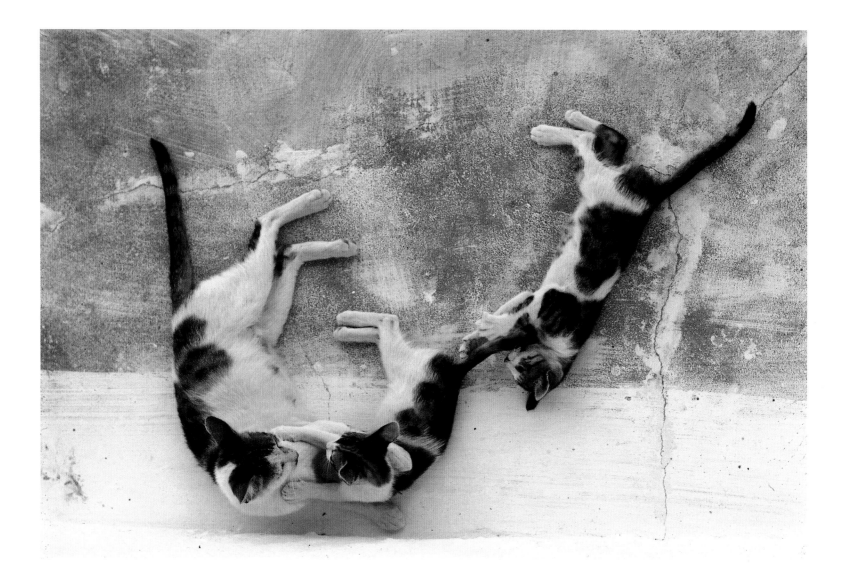

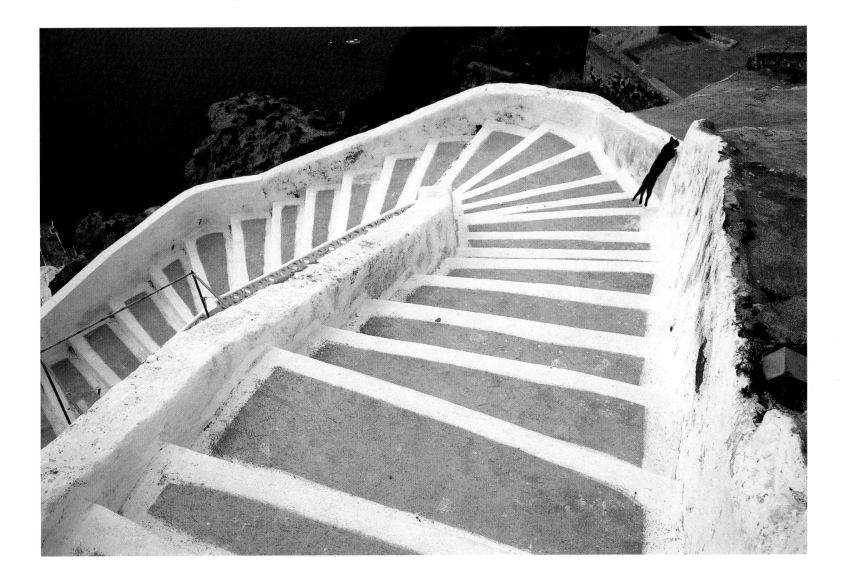

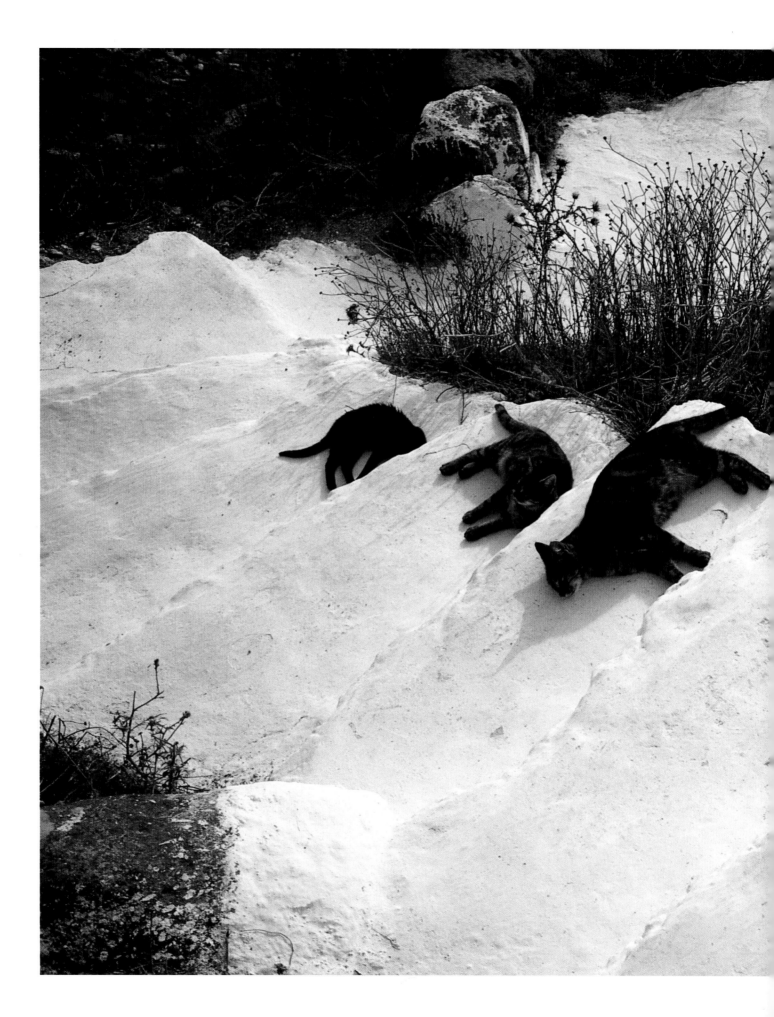

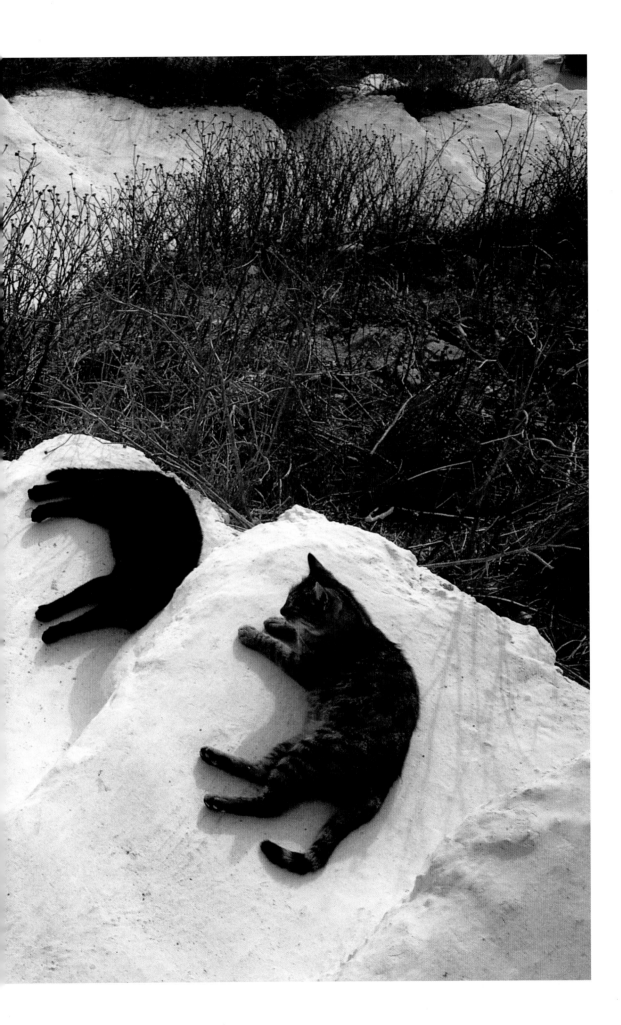

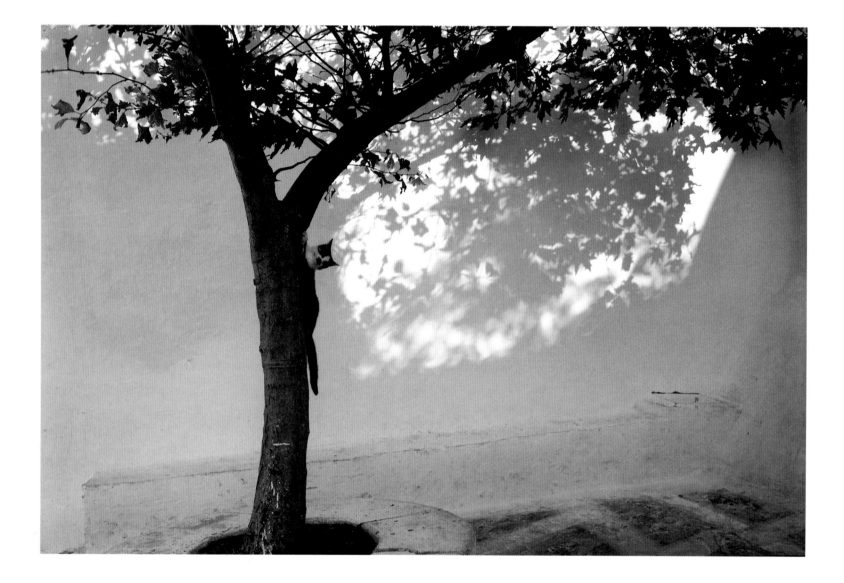

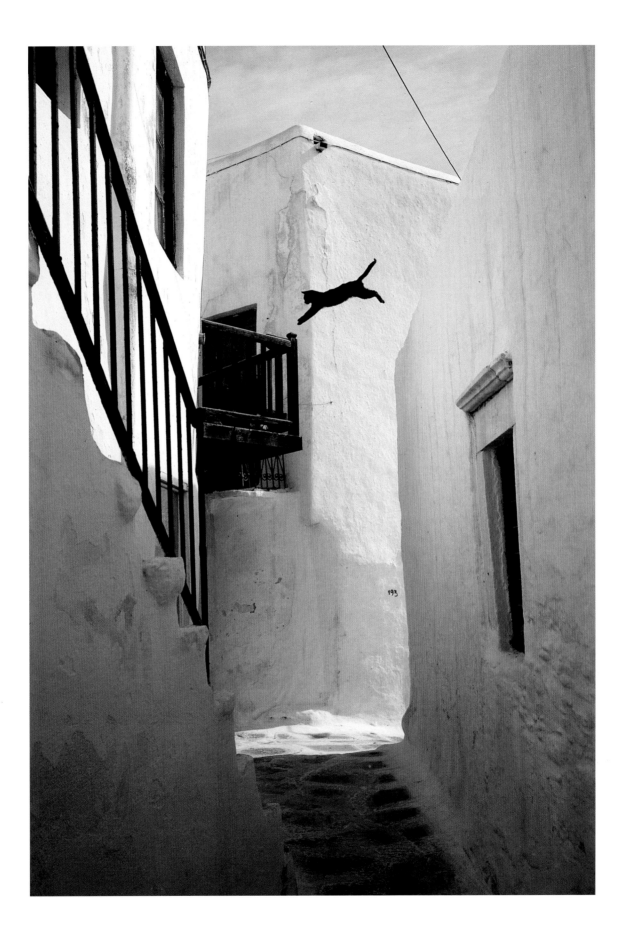

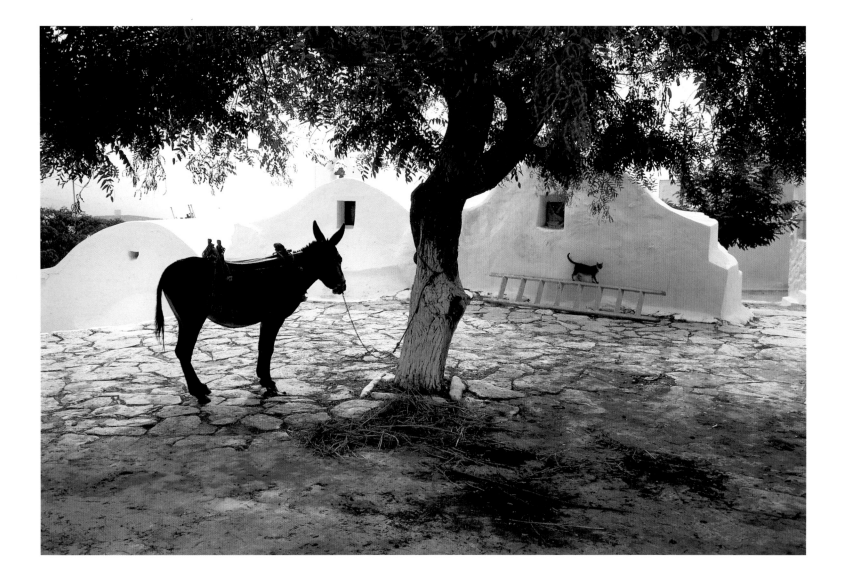

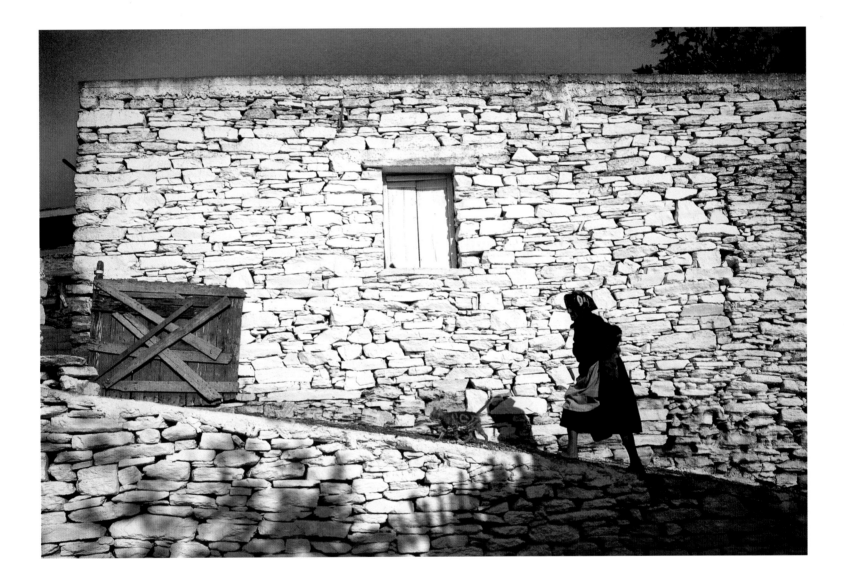

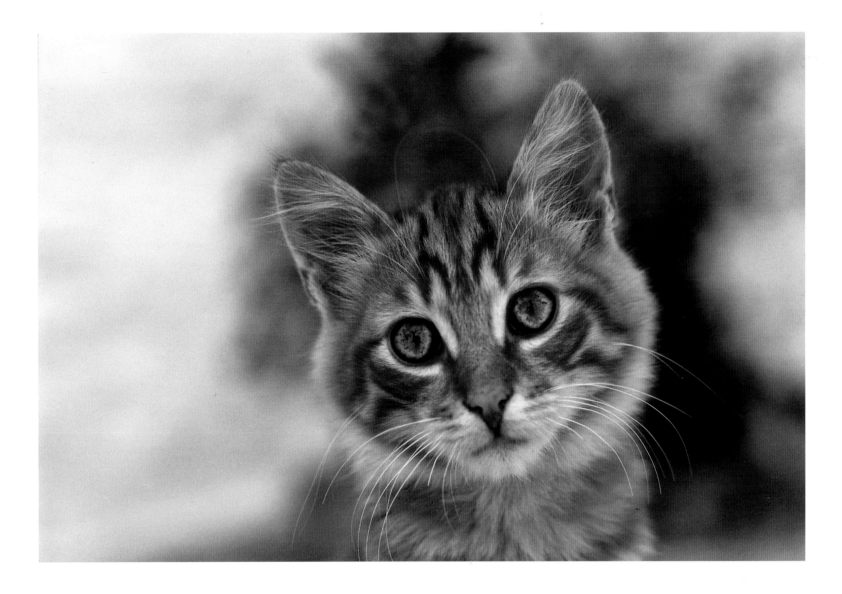

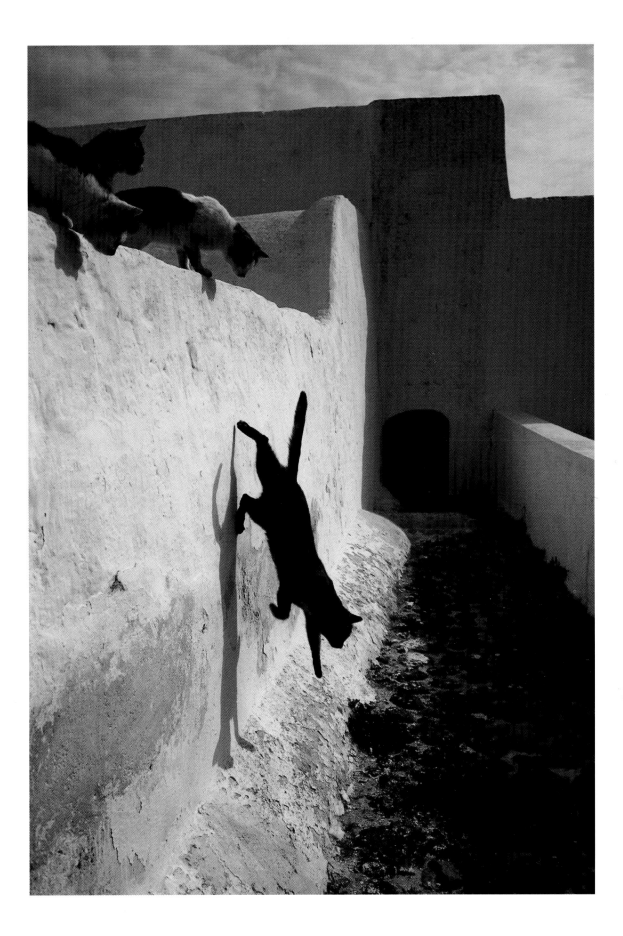

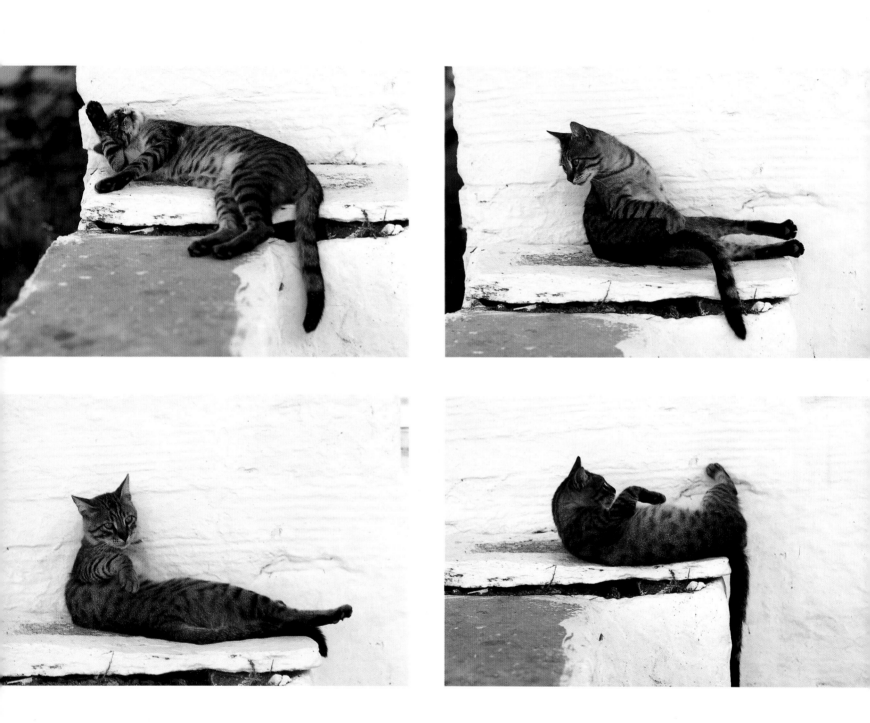

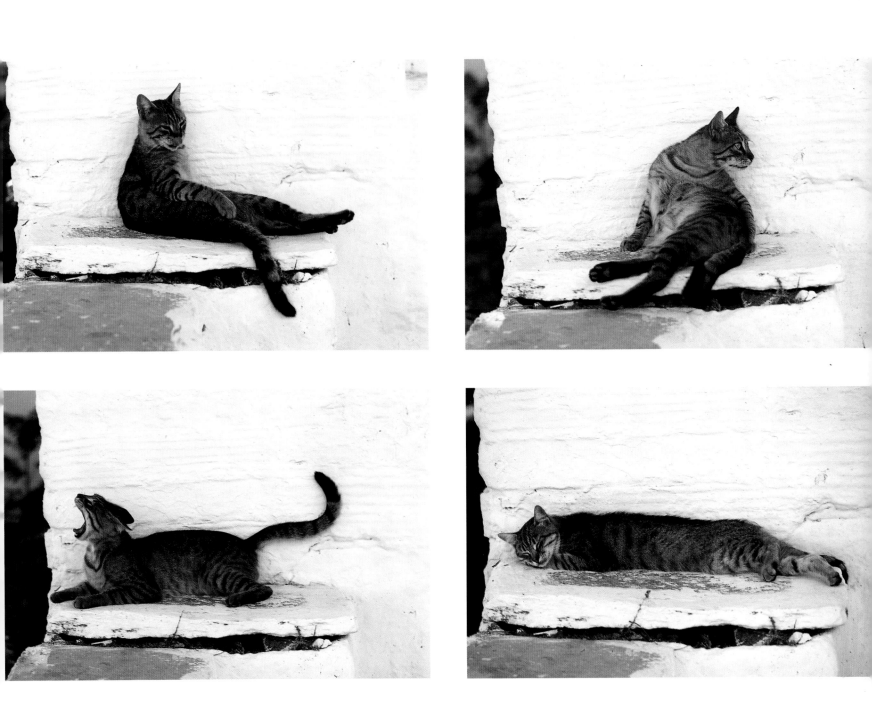

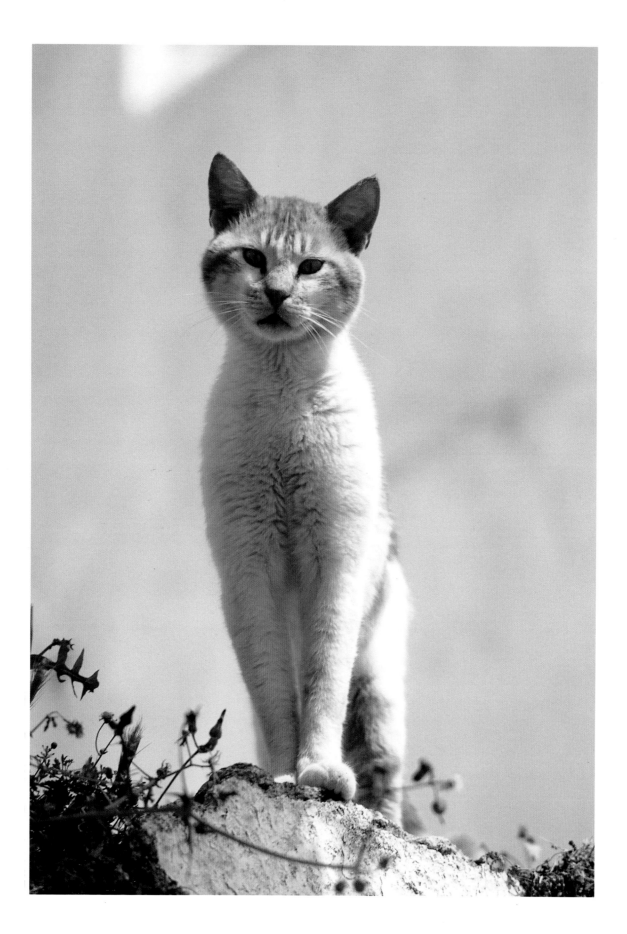

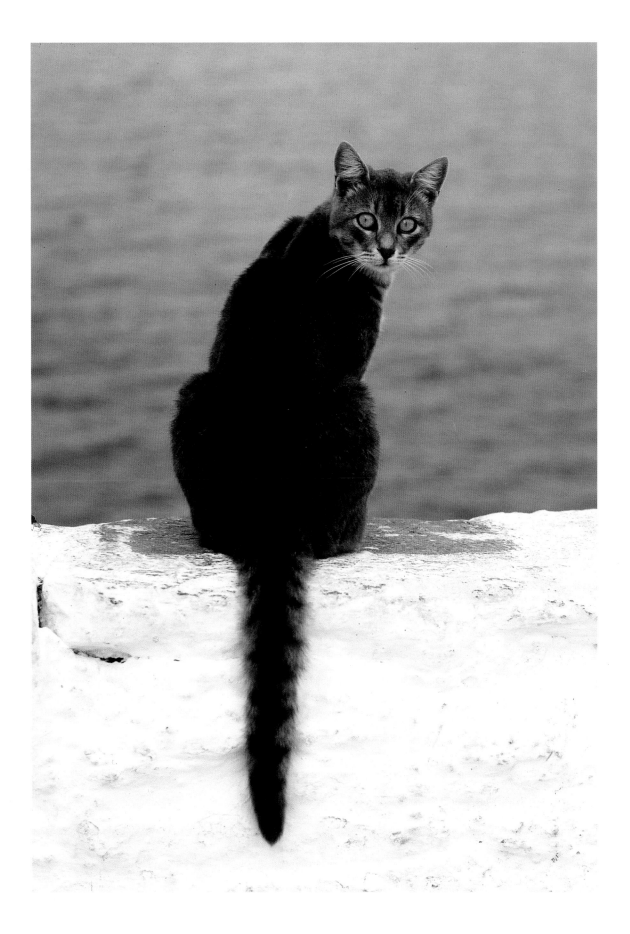

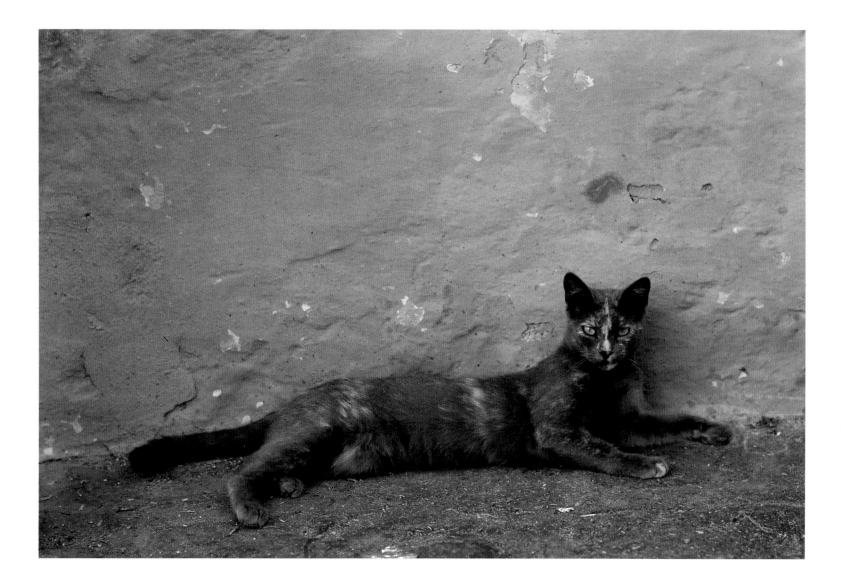

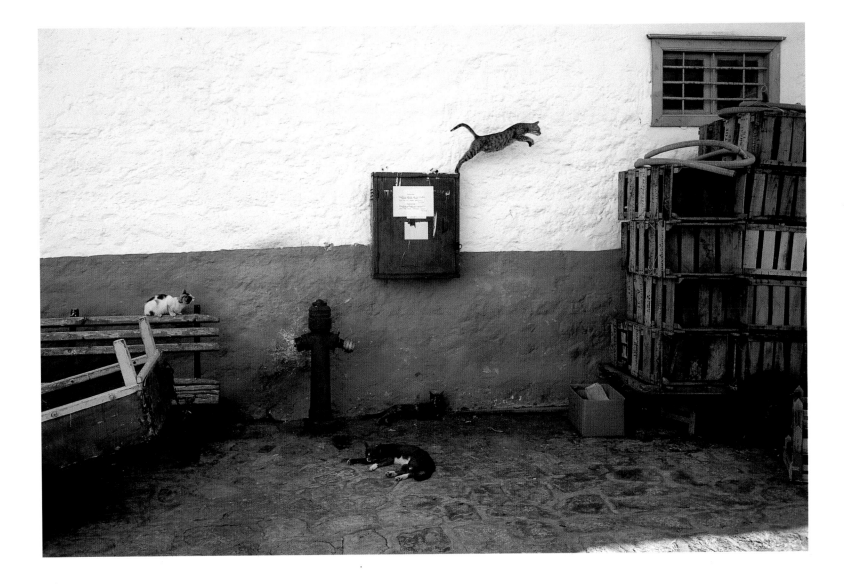

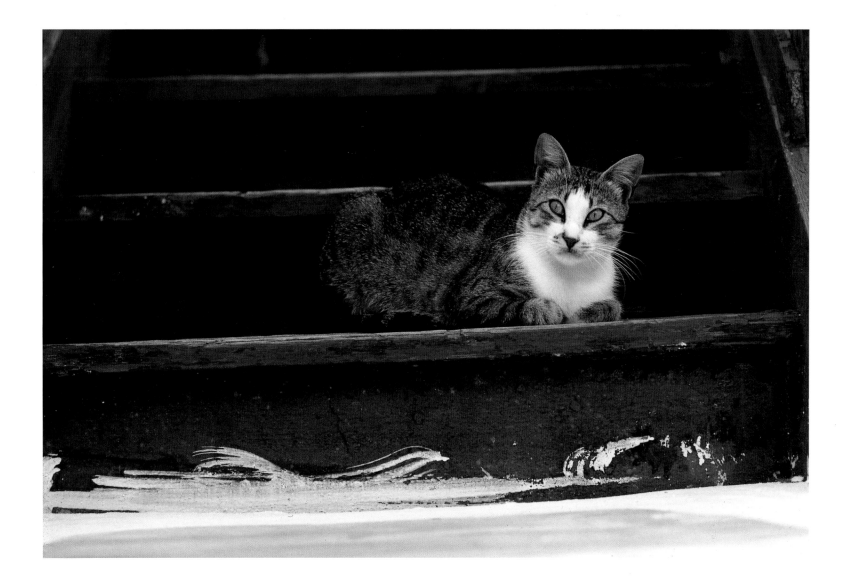

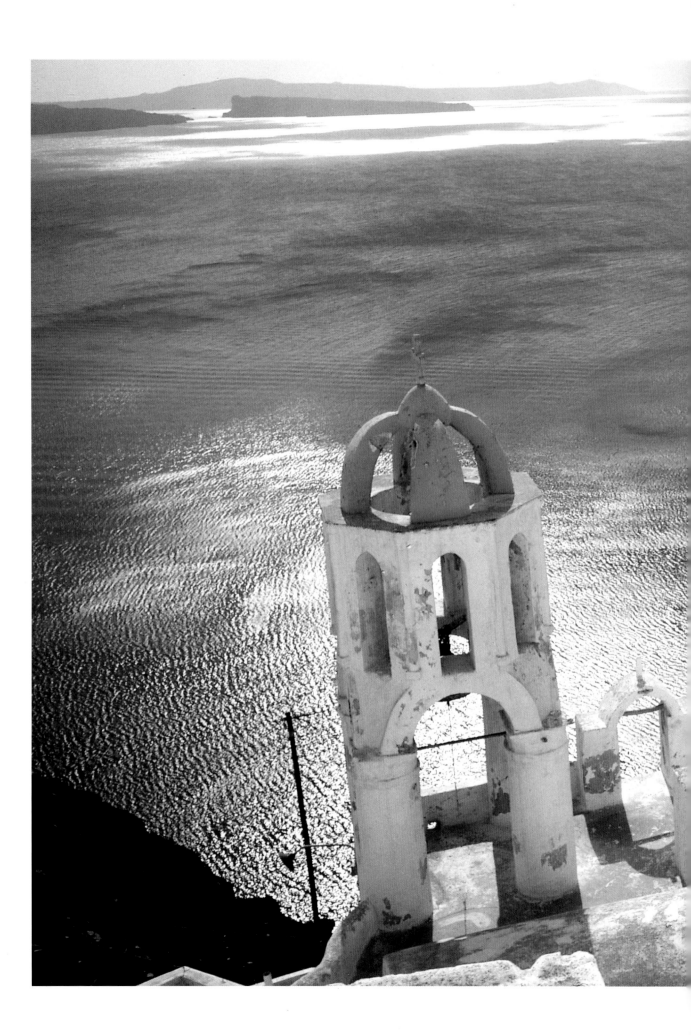

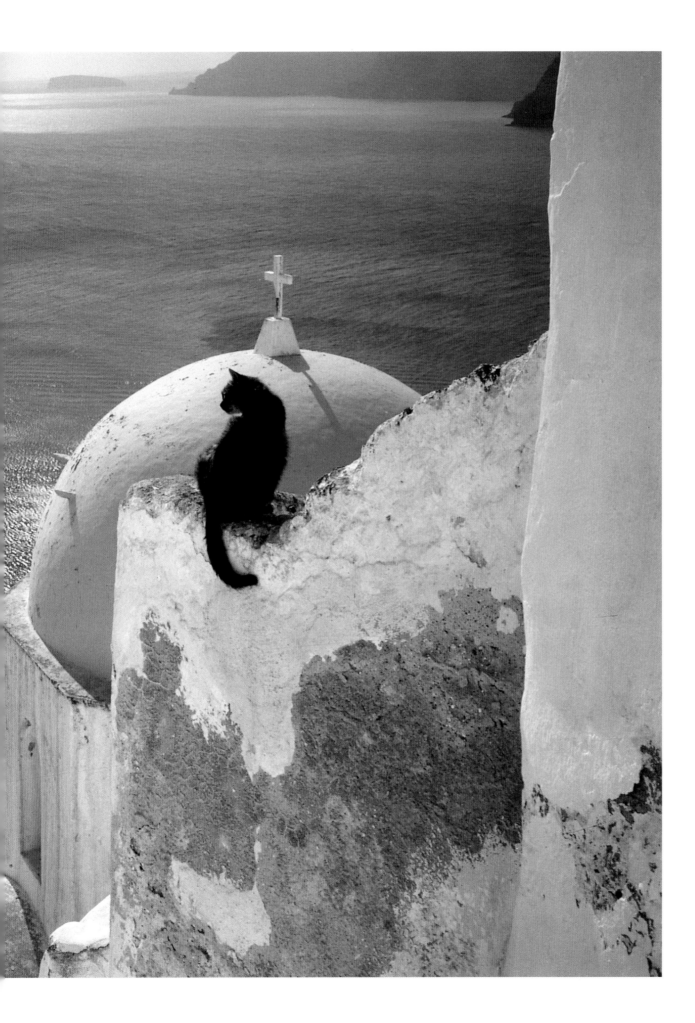

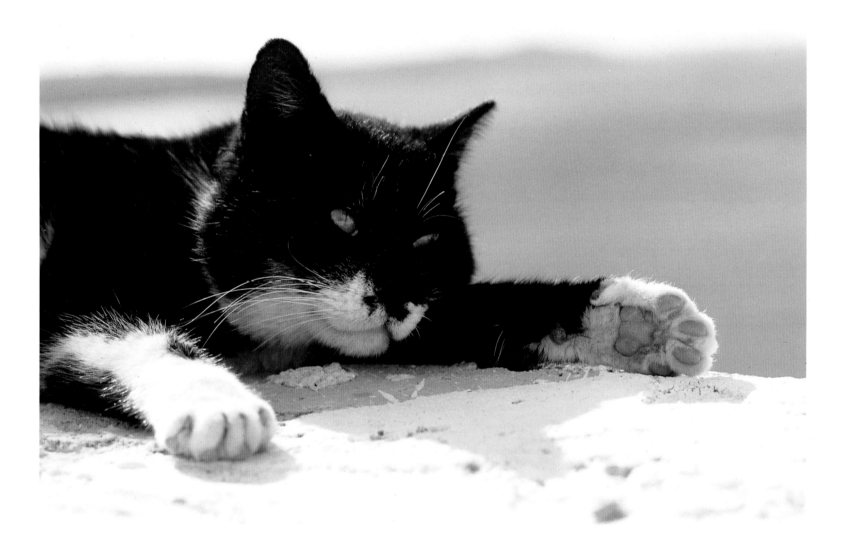

Website for this image
pet-drawings.com

Full-size image - Same size

Size: 423 × 300
Type: 121KB JPG

This image may be subject to copyright.

© 2006, 2009, E. F

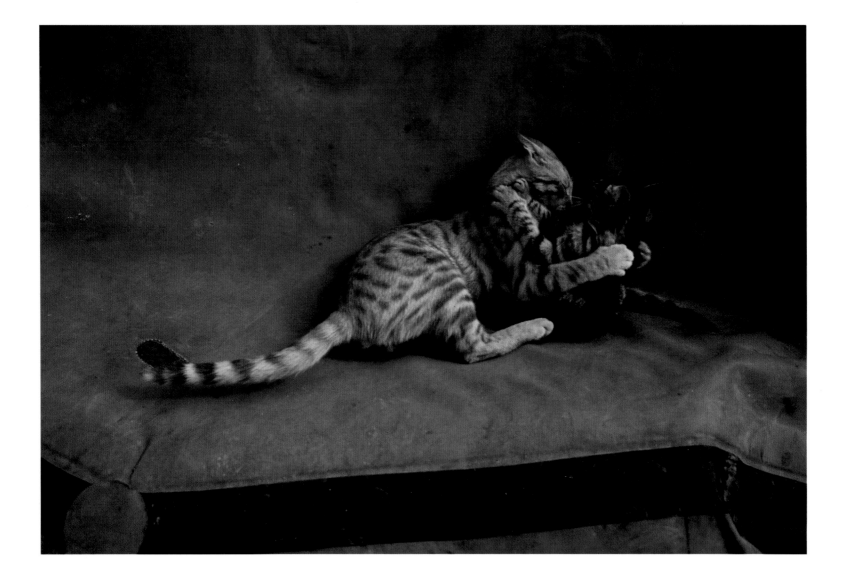

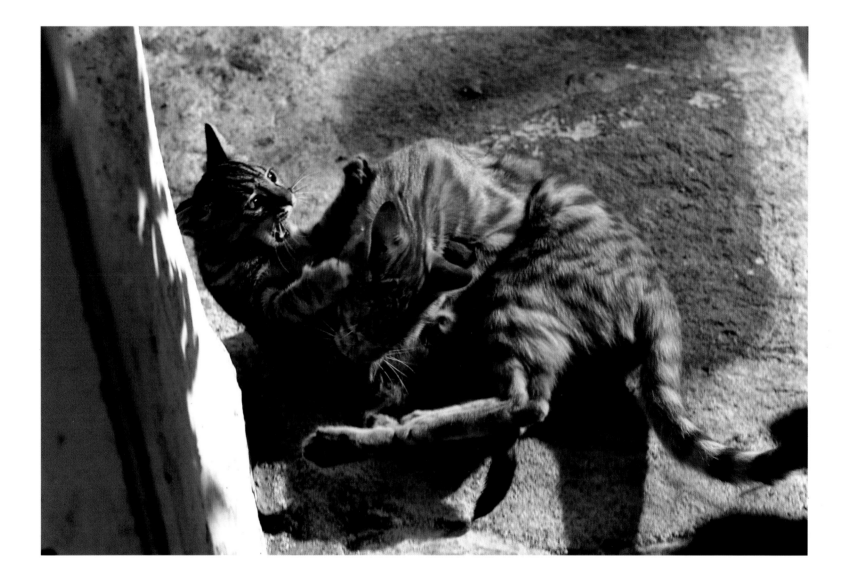

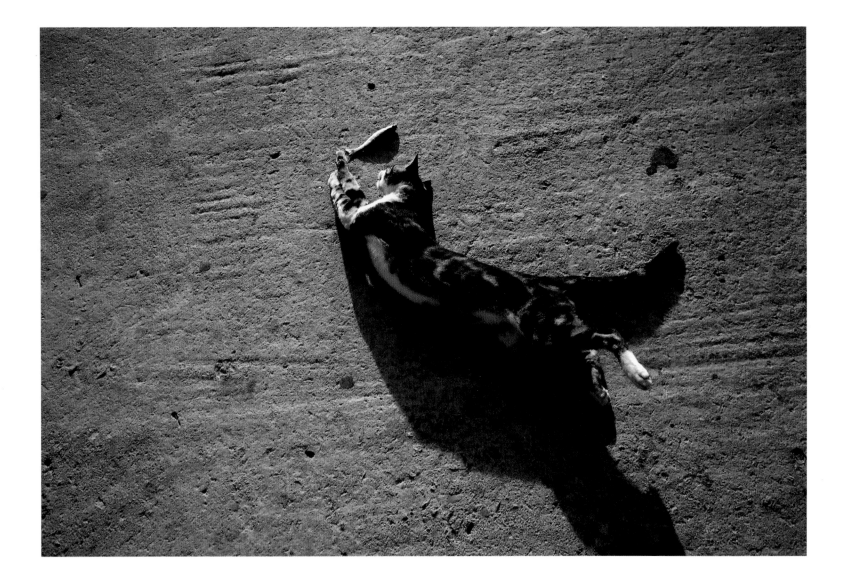

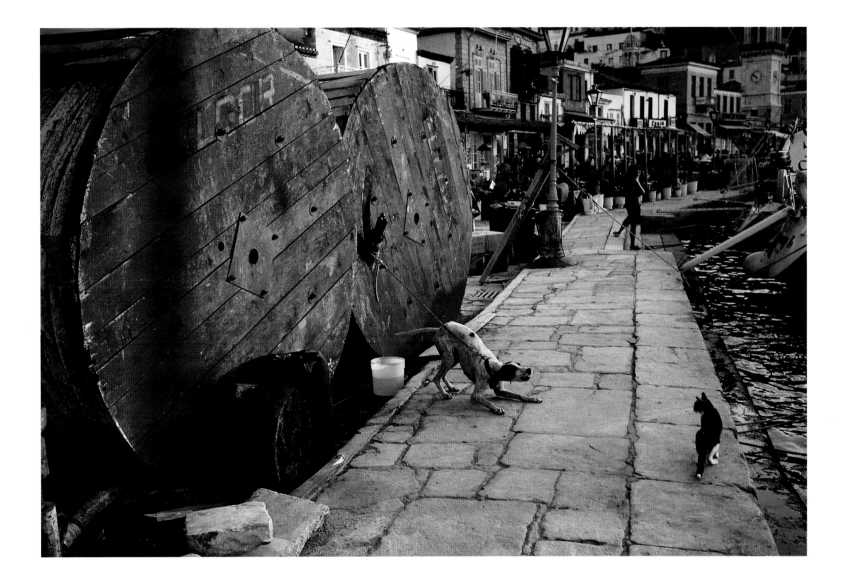

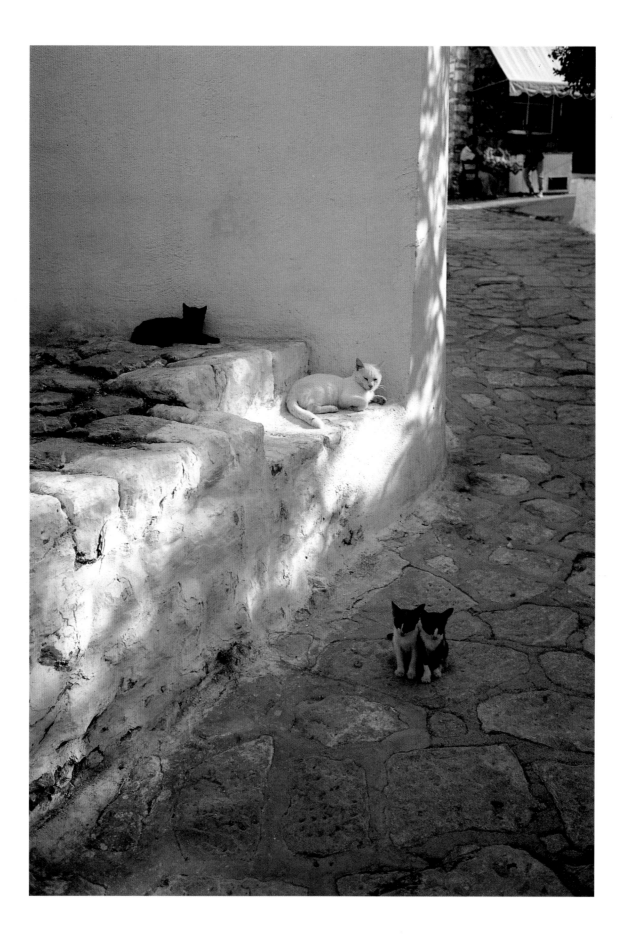

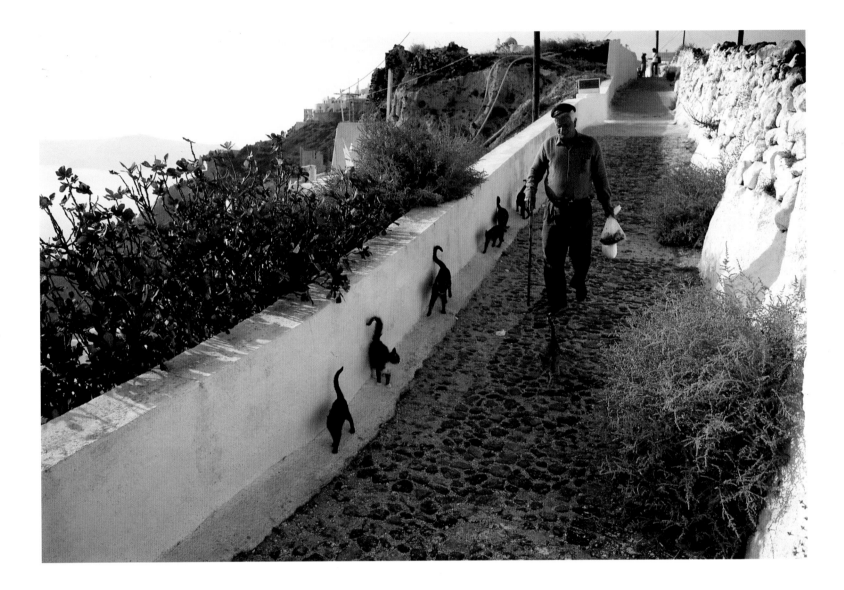

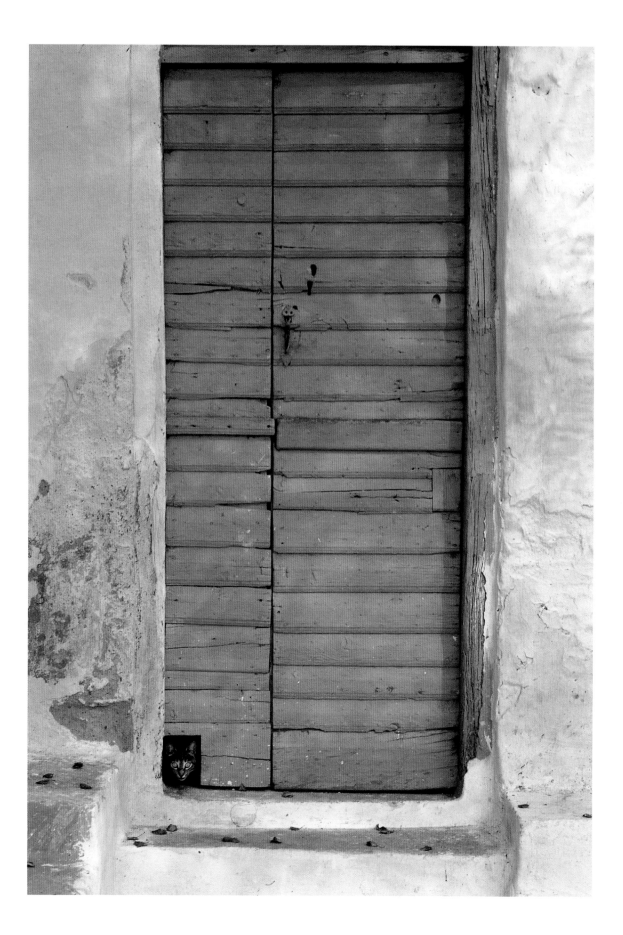

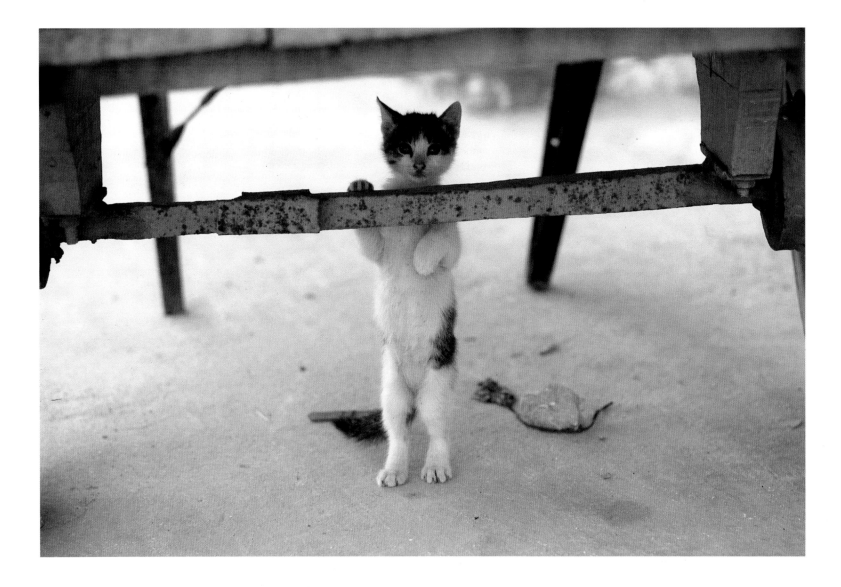

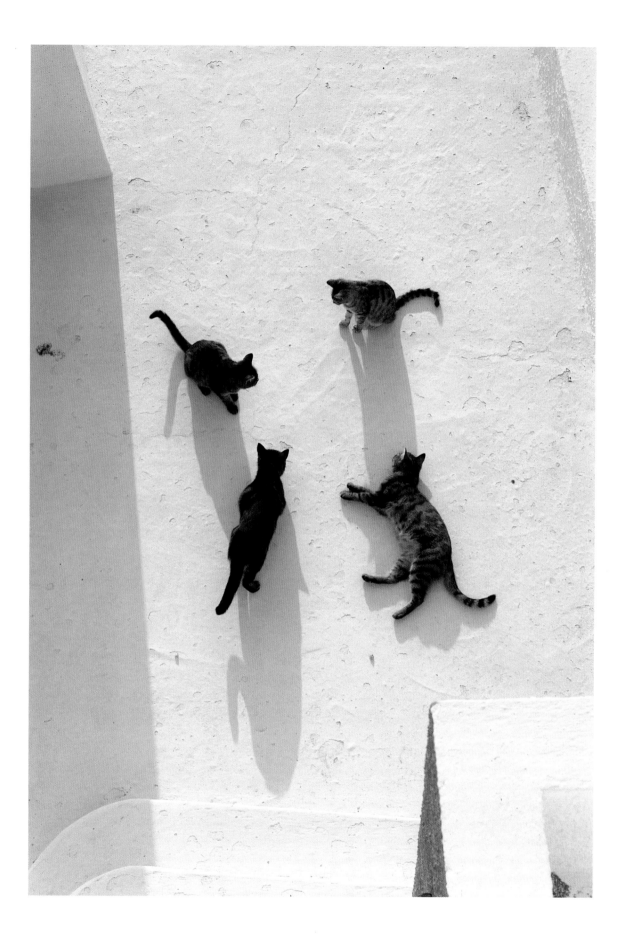

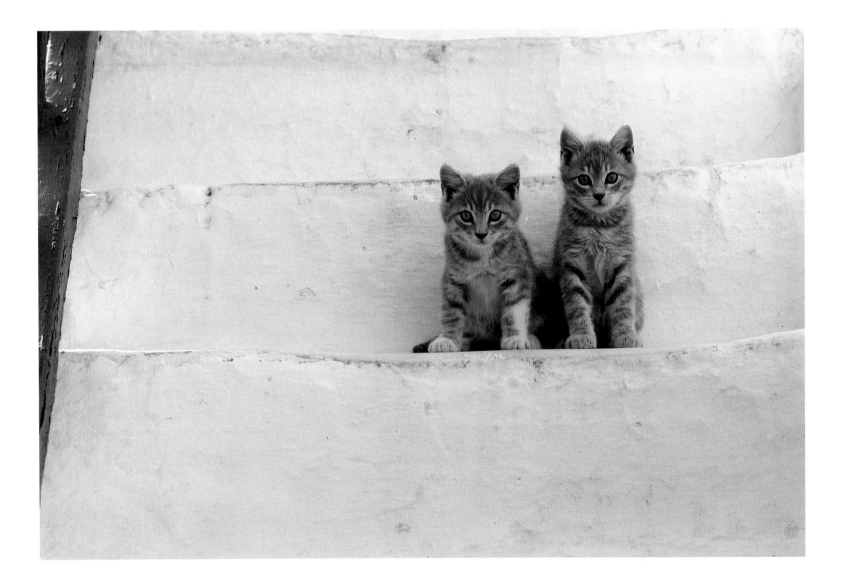

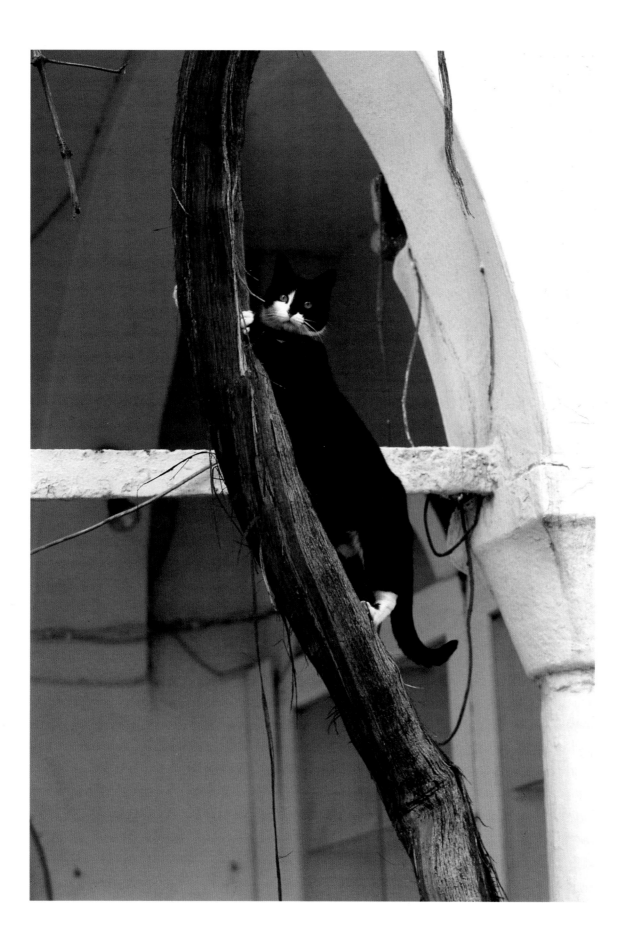

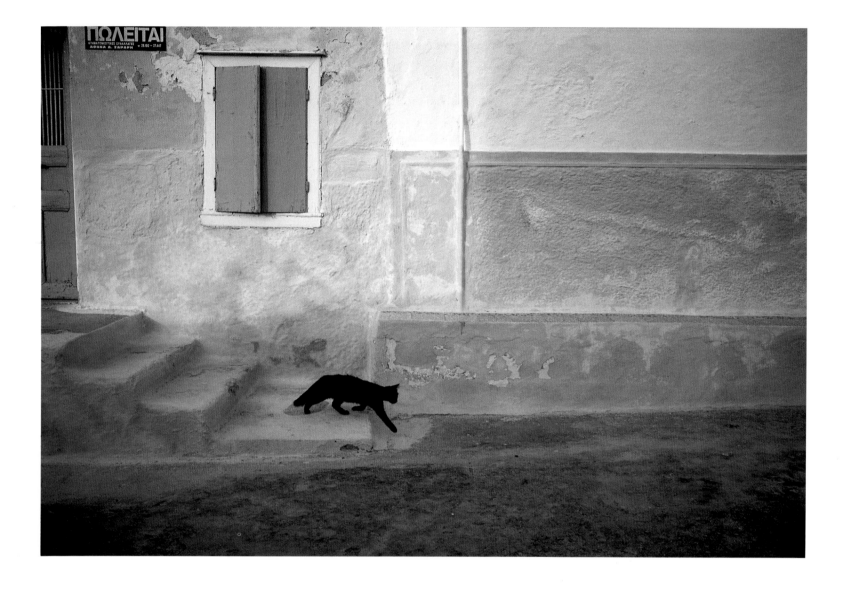

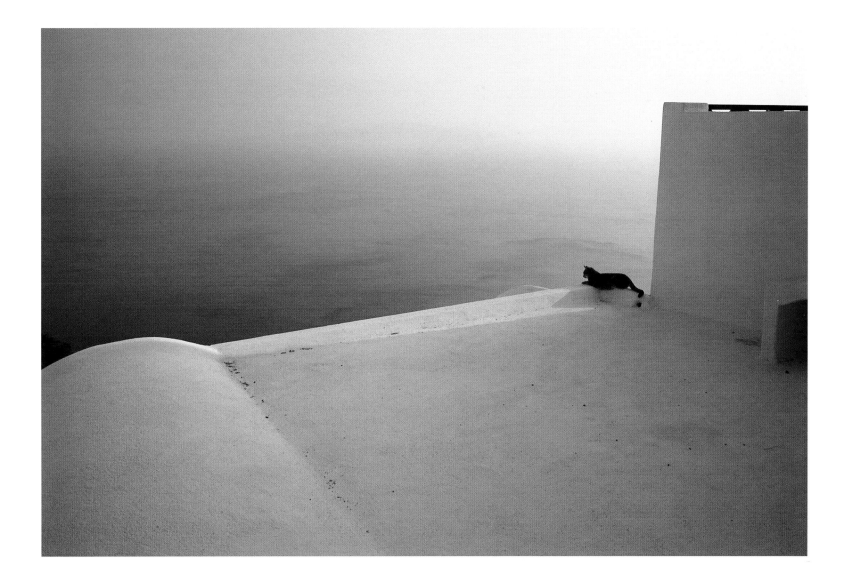

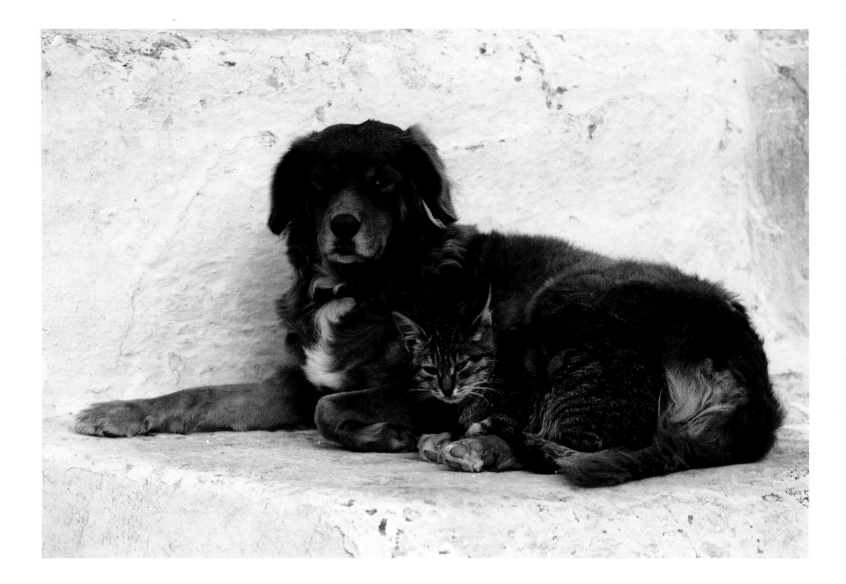

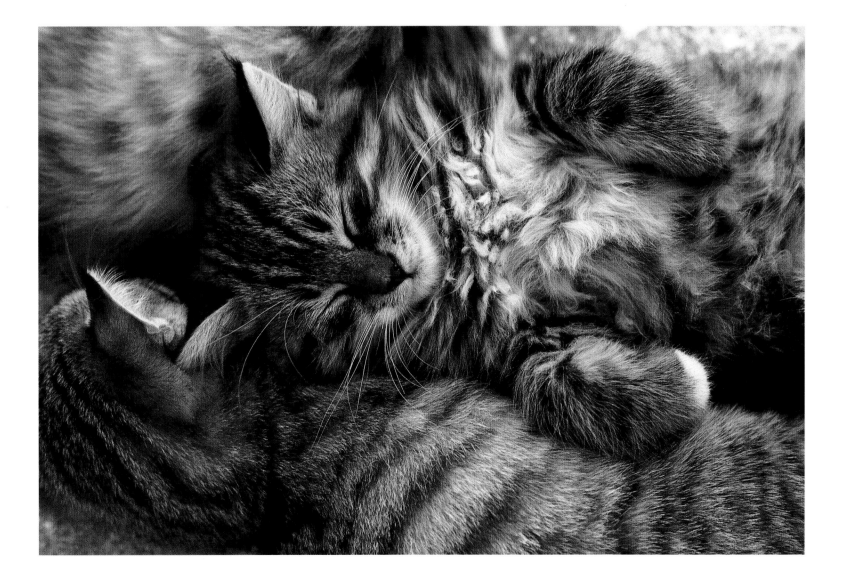

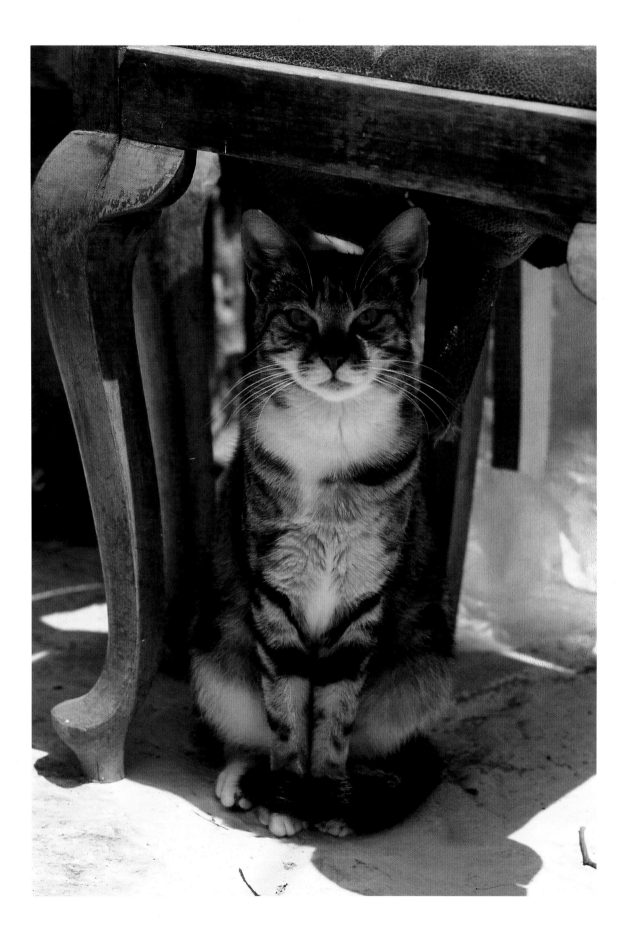

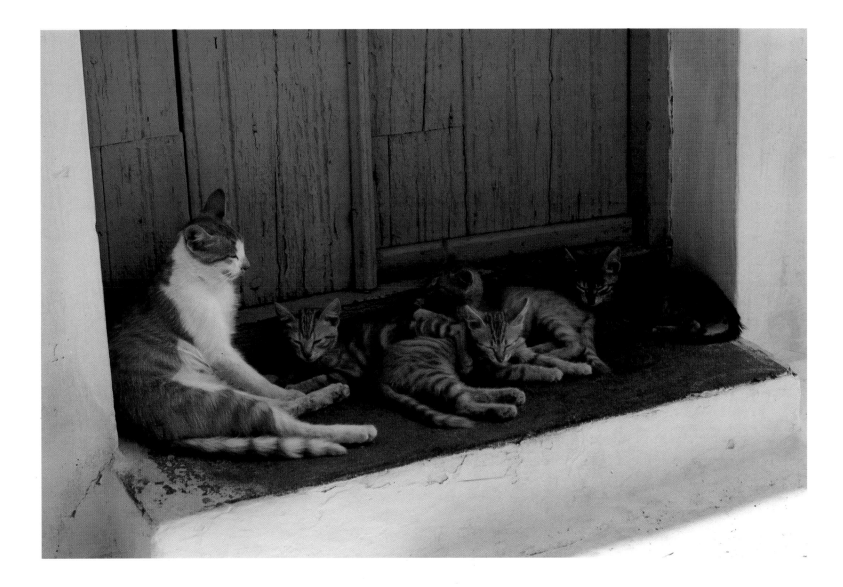

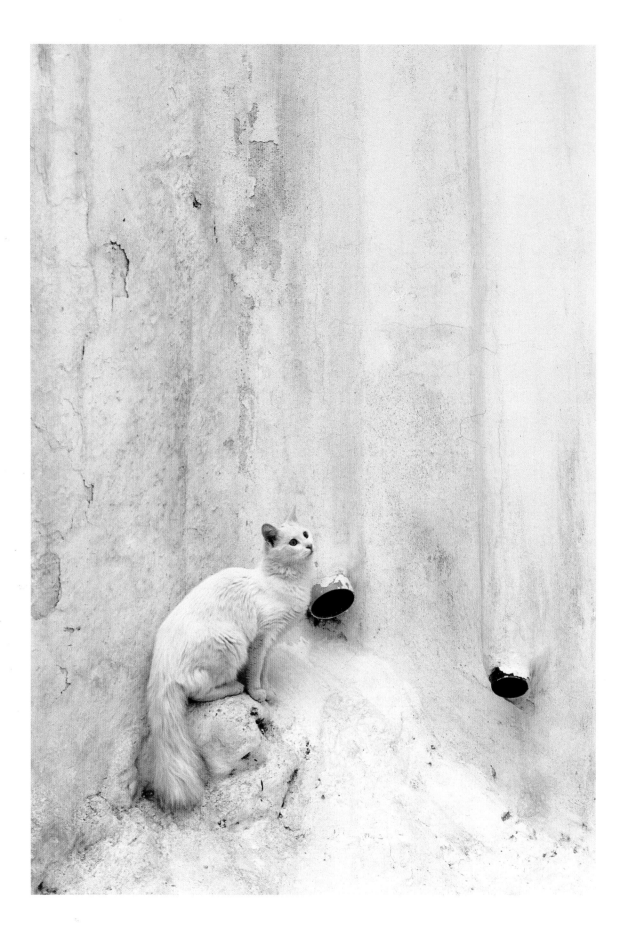

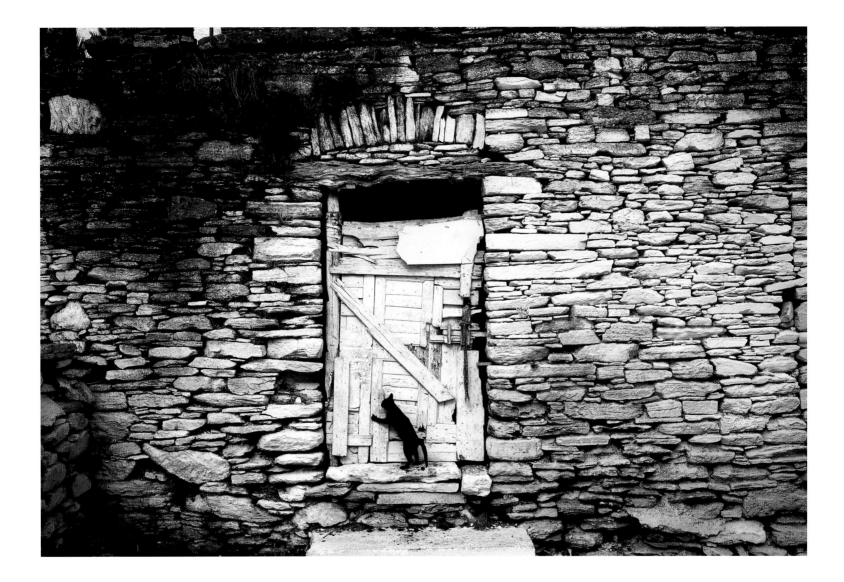

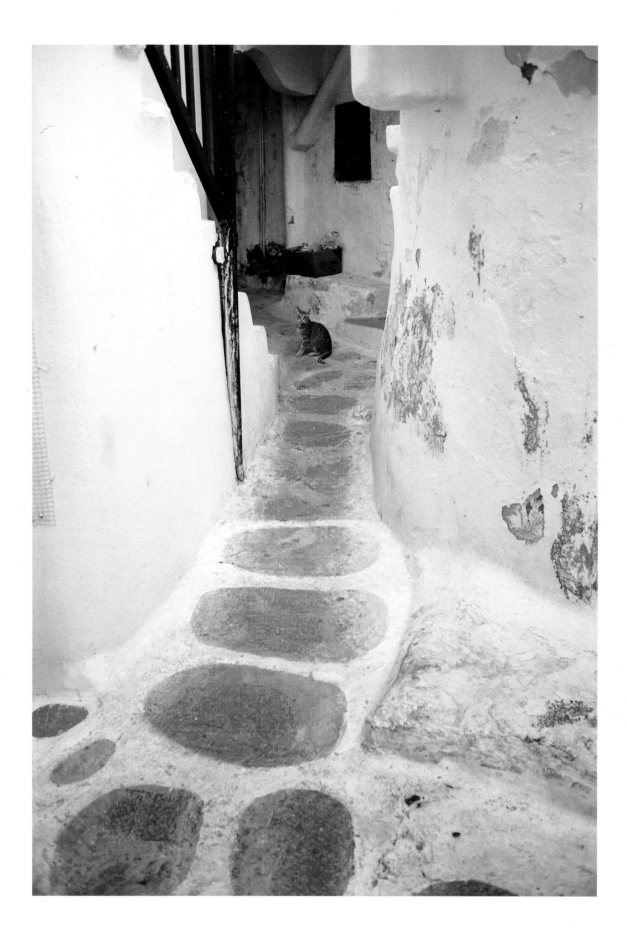

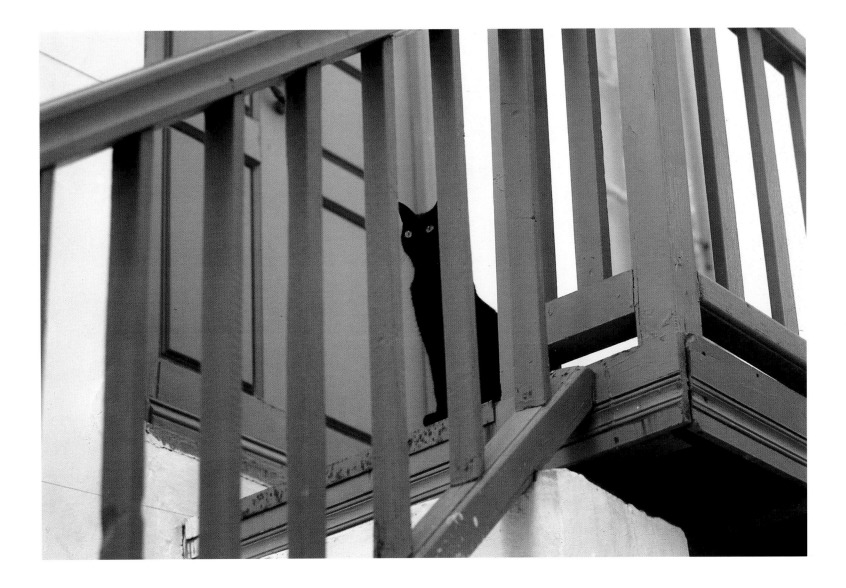

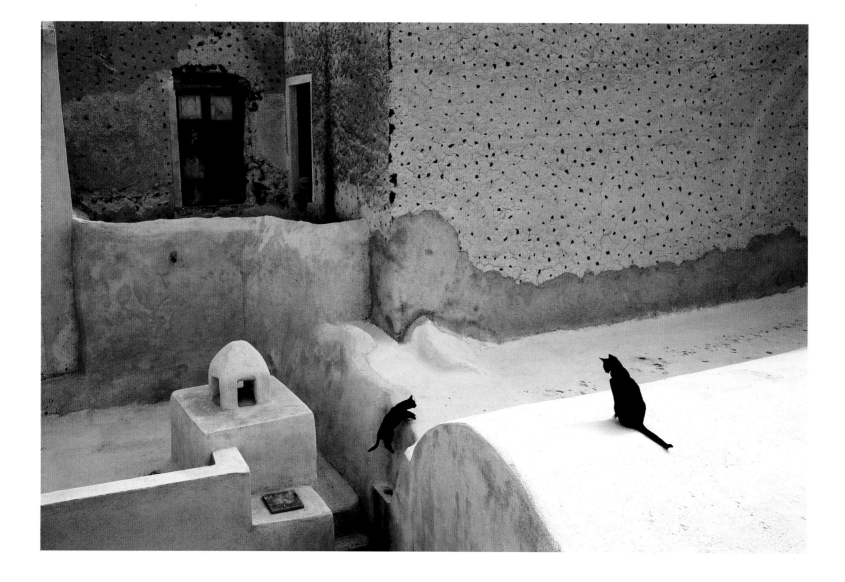

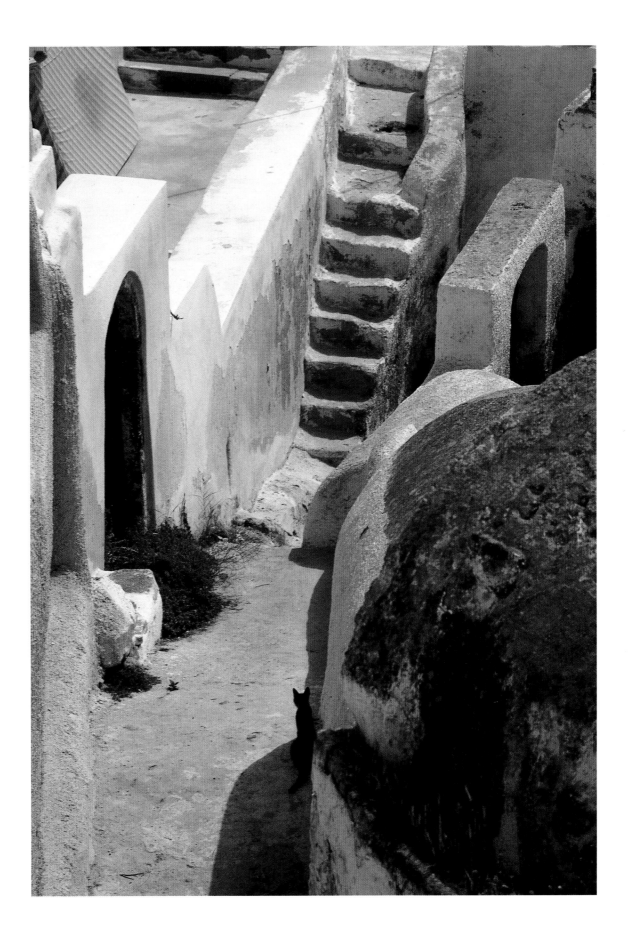

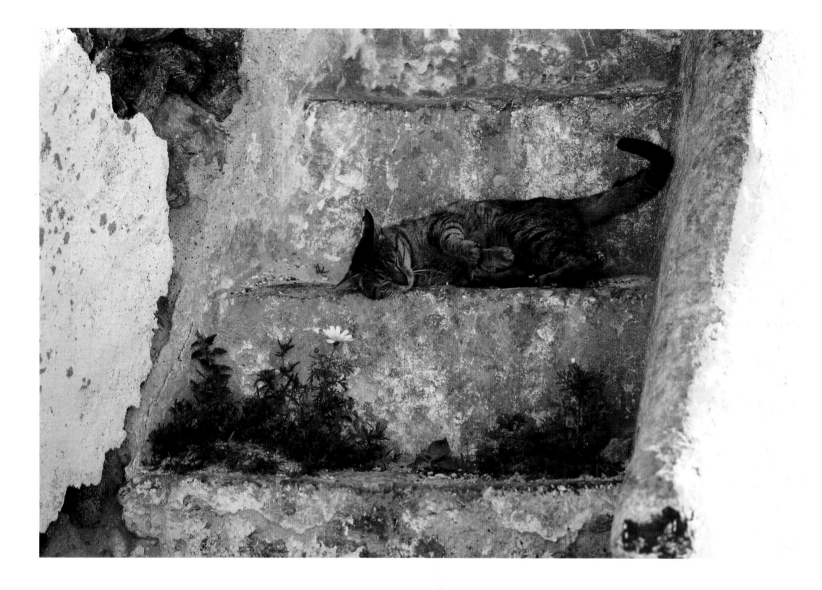

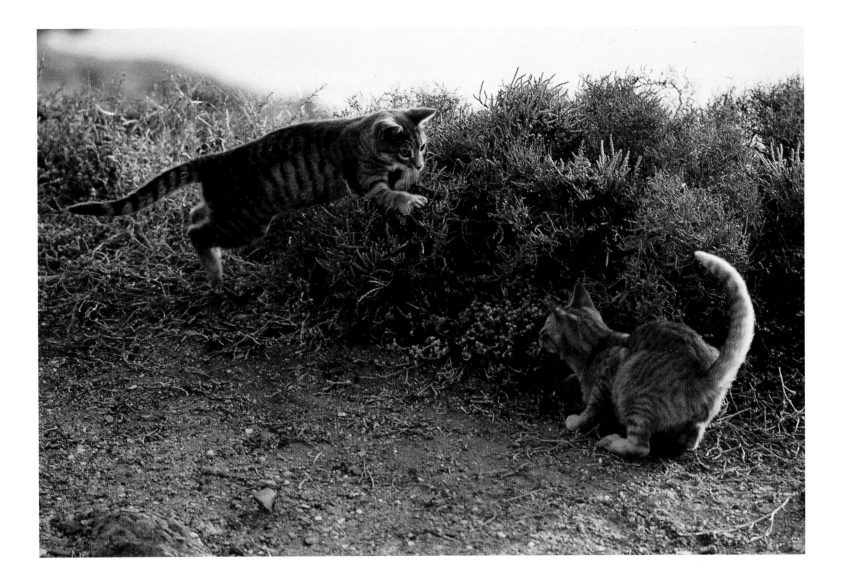

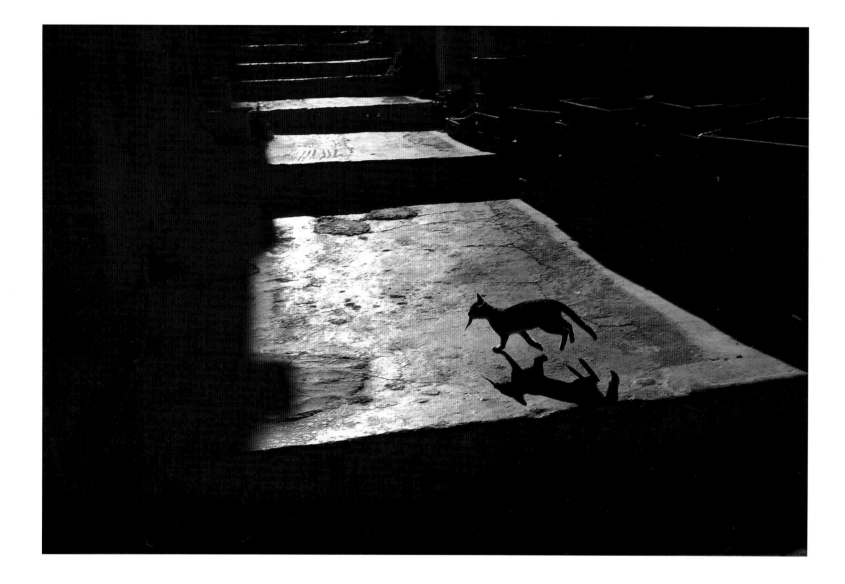

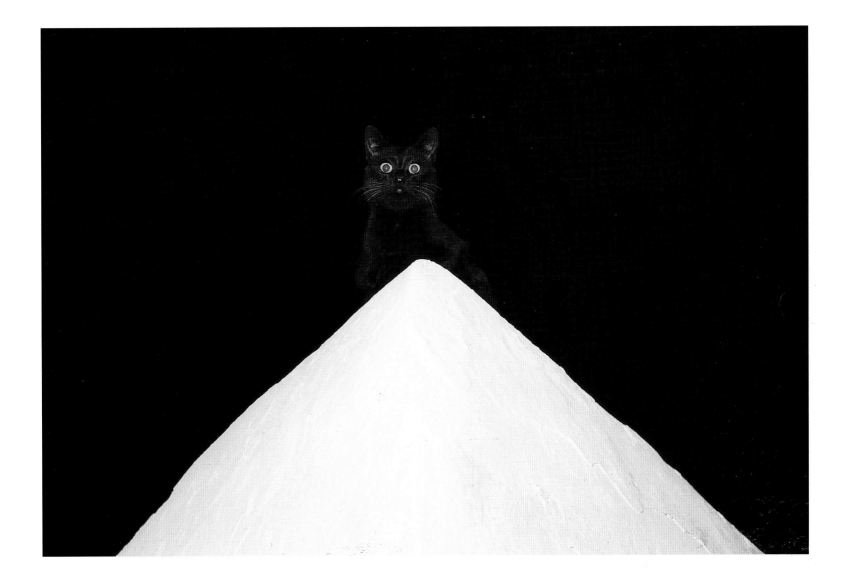

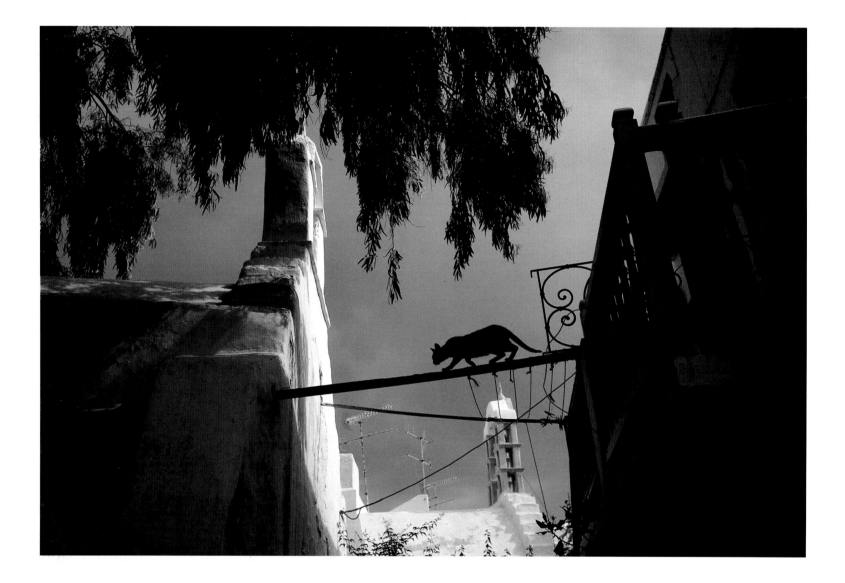

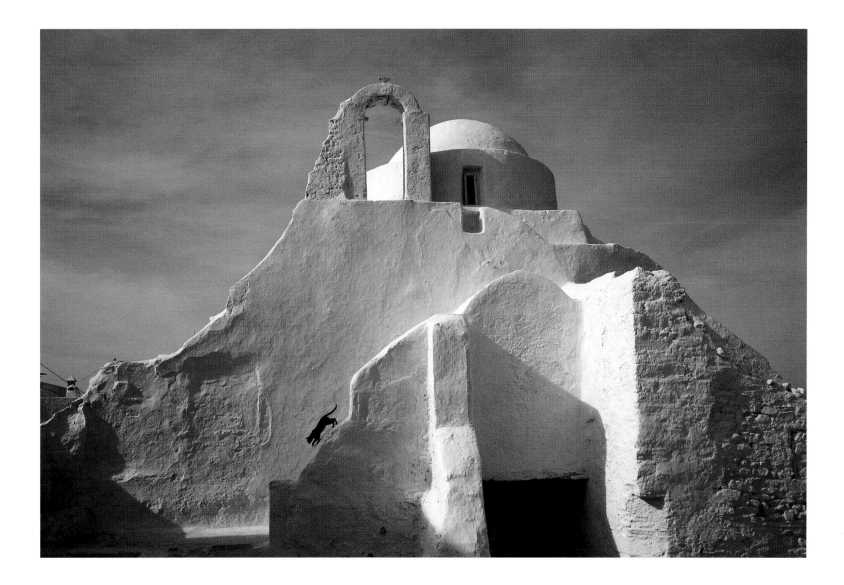

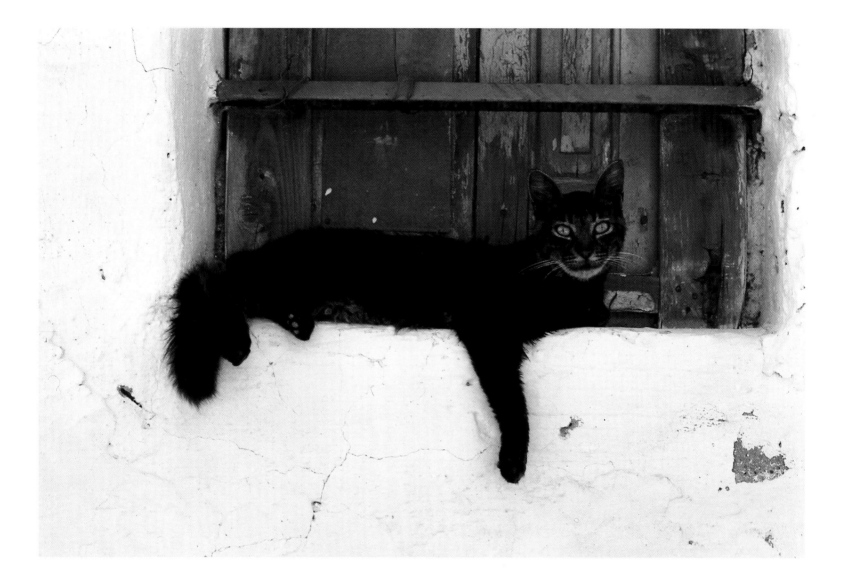

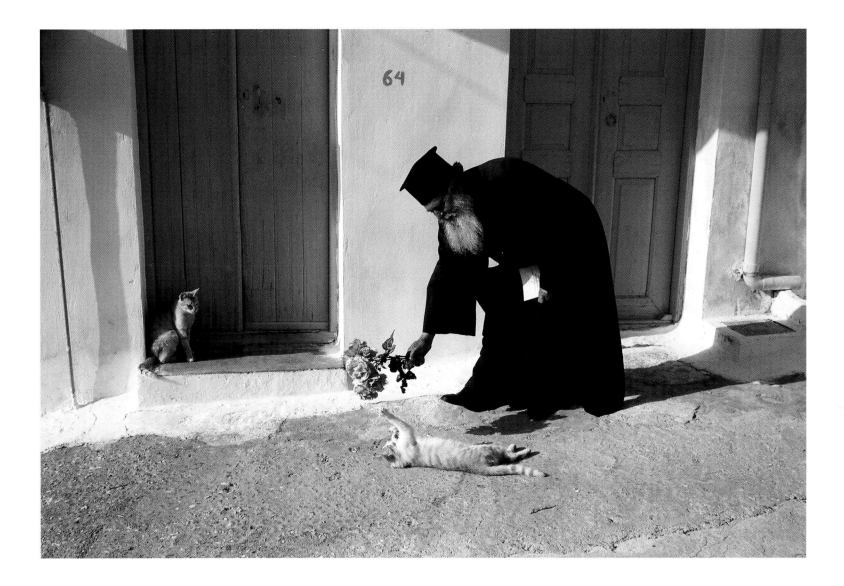

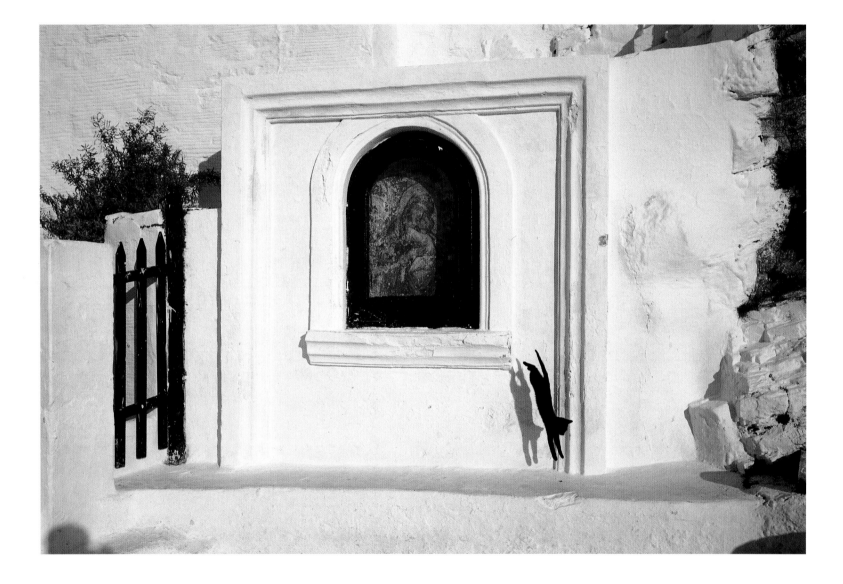

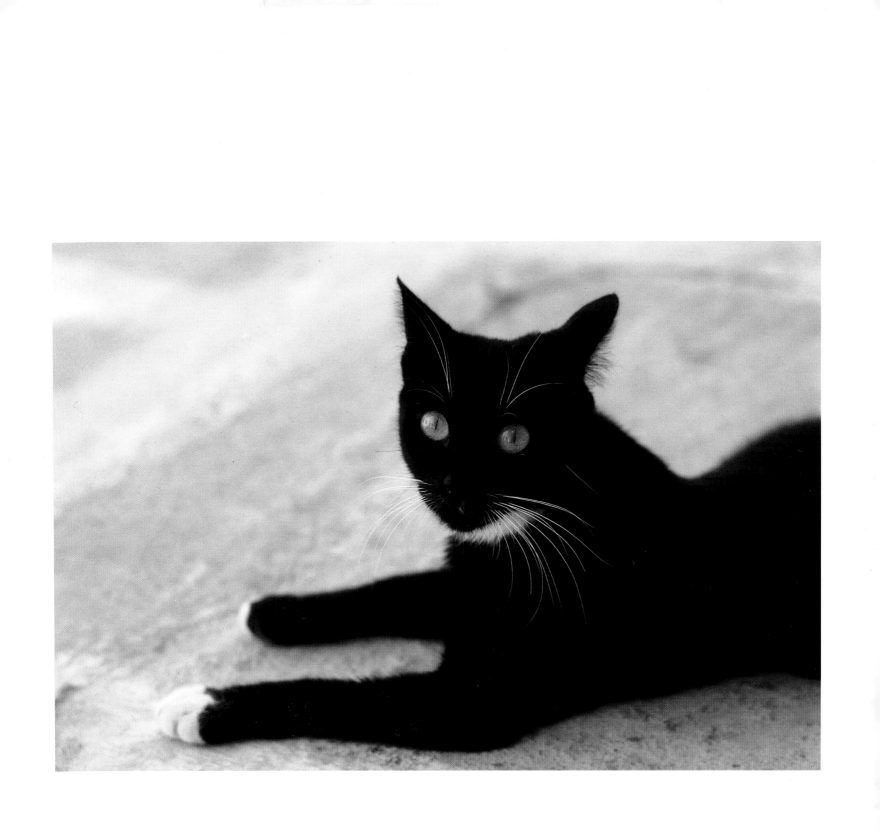

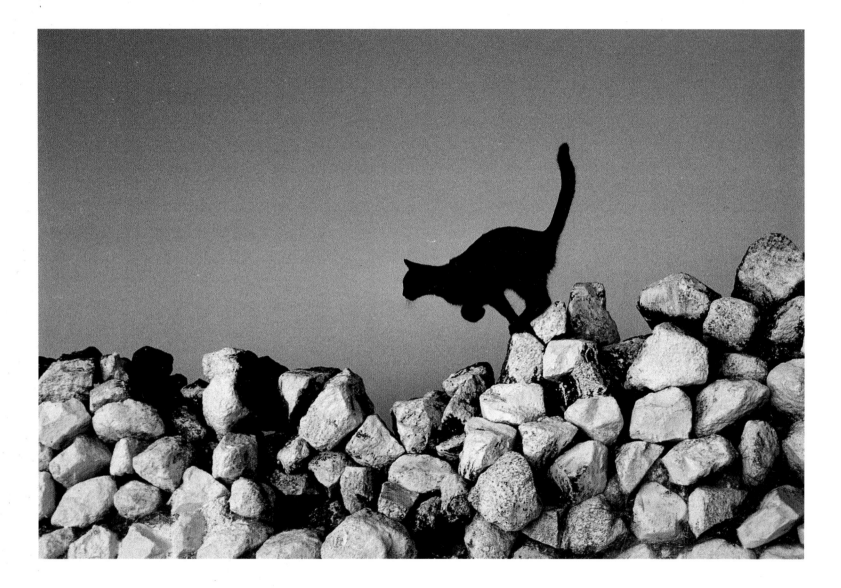